WEST VANCOUVER MEMORIAL LIBRARY

The Nude
in Canadian
Painting

Withdraw

D0772568

757.2
M87w

The Nude
in Canadian
Painting

JERROLD MORRIS

new press

TORONTO

1972

Copyright © 1972 Jerrold Morris. No part of this book may be reproduced or transmitted in any form by any means, electronic or mechanical, including photocopying and re-cording, or by any information-storage or retrieval system, without written permission from the author, except for brief passages quoted by a reviewer in a newspaper or magazine.

The author is grateful to the Canada Council for assistance towards the research of this book.

ISBN 0-88770-142-6

Design / Peter Maher

new press
Editorial offices
84 Sussex Avenue
Toronto 179, Ontario

Order department
553 Richmond Street West
Toronto 133, Ontario

PHOTOGRAPHIC CREDITS
(numbers refer to plates)

Art Gallery of Ontario 14, 56 Artlenders, Montreal 1
Arts Canada 65 John Ayriss, Toronto 27, 37, 40, 41, 60, 72
Bau Xi Gallery, Vancouver 61 Beaverbrook Art Gallery, Fredericton 49
Lloyd Bloom, Hamilton 34, 50 Capital Press Service, Ottawa 9
Dominion Gallery, Montreal 22, 24 T. Eaton Company, Toronto 36
Editorial Services, Toronto 20 Glenhyrst Commission, Brantford 10
John Glover, Toronto 2, 5, 6, 23, 35, 38, 43, 44, 51, 52, 54, 55, 58, 69, 70
R. Mendes, Toronto 42 Gilbert A Milne, Toronto 28
John Moffat, St Catharines 39, 62, 63
Montreal Museum of Fine Arts 11, 13, 29
Musée du Québec 19
National Gallery of Canada, Ottawa 4, 8, 12, 15, 16, 17, 18, 30
Robinson Photography, Thornhill 53
Gabor Szilasi, Montreal 25, 26, 32, 33, 45, 47
Peter Thomas, Vancouver 64 Winnipeg Art Gallery 57

Typesetting by Bookprint-Rapide Limited, Kingston
Printing and binding by Serasia Ltd., Hong Kong

Contents

The Nude
in Canadian
Painting

Introduction

This book celebrates the nudes in Canadian painting by presenting examples spanning a period of more than a century. Hidden from public view, evincing still the love of their authors, are numerous paintings of the nude, inaccessible to anything but the most painstaking search. For decades they have remained secluded, like the inhabitants of an old-fashioned red-light district. Even reference material on the subject in museum libraries is practically non-existent.

I hope that this essay will bring many more paintings of the nude in private collections to light and result in further research. But one can hardly enter upon such a course without stirring the depths of the national psyche. Russell Harper has written that in the late nineteenth century Paul Peel "defied the puritanical Canadian taboo against the nude",[1] and that "John Russell's skilfully painted sensuous nudes at the Canadian National Exhibition of 1927 were the cause of an unprecedented sensation in Toronto".[2]

Lest we become complacent about a supposed recent change of attitude, it would be well to remember that the shameful trial and conviction of Dorothy Cameron in a Toronto court took place as recently as 1965. She was charged with exposing obscene material in her gallery during an exhibition entitled *Eros*. It seemed at the time that the defence was too anxious to convince the court that the material was not erotic; it should rather have maintained the position that the erotic has always been regarded as a legitimate subject for artists because it is part of the human experience. The persecution suffered by Dorothy Cameron may not have been in vain, since it attracted considerable attention and protest. In 1966 a Vancouver gallery was acquitted of a similar charge in connection with a one-man show. As a prominent citizen wrote me, "The case made Vancouver feel very superior to Toronto because it came after Dorothy's run-in with the Hogtown squad".

However, the subject of our present exploration is not erotic art, but the nude. The distinction is a delicate one, not always easy to make. I can vouch for the fact that visitors to galleries often look sideways at paintings of the nude and mutter something like, "Great, but we have children in the house". And of course they are quite right if they consider information about the human figure to constitute carnal knowledge.

It is inevitable that depiction of the nude should often stir feelings of sensuality inherent in our nature. Art has always satisfied refined and undemanding yearnings. In some cases it has provided a considerable portion of an individual's sensuous experience. Flaubert, for instance, was constantly fall-

ing in love with works of art, ranging from Canova's neo-classic marbles to a madonna by Titian. I learned to love Pre-Raphaelite ladies long before I became interested in girls. But in Canada, people have had a depressingly prudish attitude to art. Can it be pure coincidence that the Centennial exhibition assembled by the National Gallery of Canada, titled *Three Hundred Years of Canadian Art*, comprising 375 works from over 100 different sources, should have included only one picture which could be identified as a nude?

What concerns us specifically in this essay is the nude as subject matter for Canadian painters, and the various ways in which they have incorporated it into the content of their work.

Throughout art history, the human figure has been used for expressive purposes. A glance at the chapter headings in Kenneth Clark's magnificent book *The Nude* reveals the range – Apollo, Venus, Energy, Pathos, Ecstasy. The works he discusses span a period of more than 2000 years, whereas the history of the nude in Canadian art covers little more than the last century and is subject to the limitations of that time. Few Canadian nudes are energetic, pathetic or ecstatic. Most fall either within the Venus group, reflecting adoration of the female figure in various adaptations of the classic Greek ideal, or in the category called by Clark "The Alternative Convention", originally derived from the Northern Gothic style – anti-classical, realistic or expressionistic.

Apollo, the male nude, has rarely appeared in Canadian art and then only very recently. It is obviously regarded as being highly provocative. In an exhibition in 1970 at Hart House, University of Toronto, a painting by John Boyle containing a male nude was emasculated.

The sexual attributes of the male nude add little to its heroic, formal characteristics, and this may be the reason, beyond modesty, that they have attracted so many fig leaves. Rodin solved the problem in his bronze *Death of Adonis* by omitting them altogether. The number of occasions one can recall in which an explicit representation of the male nude in a work of Western art has been triumphantly achieved are few, most of them sculptural. Among them are early Greek figures, Michelangelo's *Captive*, Cellini's *Perseus* and Donatello's *David*.

The Colonial Period

During the 250-odd years of its history as a colony (or rather several colonies) Canada relied for its paintings on European artists, either visiting or settling here, or on local artists, often

imperfectly trained. Our first two paintings of the nude belong to this period.

Cornelius Krieghoff, who came from Amsterdam, was to become renowned as a recorder of habitant and Indian life in Quebec. His earliest paintings reflect his European training and his experience in copying old masters. His *Nude* of 1844 (Pl 9) was thought by Marius Barbeau[3] to be a study of the artist's wife, Louise. Although it is a sterile and mannered composition based on eighteenth-century models (with an echo of the haunting paintings of Henry Fuseli), it is an attractive picture.

Many Canadian-born artists of the colonial period could be described as primitives. They were without professional training but their paintings have an expressive quality which transcends their lack of skill. Two kinds of primitive painters can be distinguished: the first consists of artists whose very efforts to overcome their technical difficulties result in a sort of awkward charm or power; the second, of artists whose total disregard of all accepted standards of professionalism enables them to arrive at a uniquely poetic means of expression.

Robert Whale was mostly self-taught, and although his paintings achieved a modest standard of competence, based on a study of Reynolds and romantic landscape painters such as Turner, the naive quality of much of his work is characteristic of primitives of the first kind. He is best known for several paintings of the railway skirting the Niagara escarpment, but he also painted a number of idyllic scenes like his *Bathers* (Pl 10) of 1866, in which the background setting may well be the valley of the Grand River near his home.

The Academy

The Royal Canadian Academy was founded simultaneously with the National Gallery of Canada in 1880. In the late nineteenth century, sanction for the introduction of nude subjects by members of the Royal Canadian Academy was, to a large extent, founded on the Paris Salon. As Harper has noted, by 1893 twenty-five Canadians were attending the Ecole des Beaux-Arts or schools such as Julian's or Colarossi's, and their teachers included the famous academicians Cabanel, Gérôme, Carolus-Duran, Boulanger and others. Because the Academies of Britain and France (and hence Canada) considered themselves guardians of the heritage of the great art of the past, with a duty to encourage its emulation in their members and pupils, the character of academic art tended to be a rehash of historic styles overlaid with contemporary taste.

On election to the Royal Canadian Academy, each acade-

mician was required to deposit a diploma work in the National Gallery of Canada. An analysis of these pictures before 1900 gives a clear indication of what was then considered right and proper in a picture. The universal reverence for the "history picture" of the early nineteenth century had given way to an equally universal admiration for narrative or genre subjects, usually sentimental and often coy. The diploma picture of John Colin Forbes portrays a young lady manipulating a fan and is titled *Beware, I know a Maiden fair to see: Take Care!*. Gustav Hahn's entry is called *Hail Dominion!* and represents another young lady dressed in Botticellian robes spreading protective arms around nine angelic little girls. (It might have been appropriate to hang this painting in the halls that hosted the Victoria Constitutional Conference in 1971.) Landscapes, which used to be regarded as inferior subjects, were now acceptable. Twelve of them are included in the diploma works. All are in the European fashion; indeed, Harlow White's *The River Conway, North Wales* is indistinguishable from the Canadian scenes. There are two seascapes and three still-lifes — all the rest are genre subjects. No nudes.

Yet academicians were painting nudes as a matter of course. Only some vast iconoclastic repression, such as occurred during the Byzantine period, could prevent artists from treating the human figure as a prime subject for painting. It was a most important part of their training. From the foundation of schools and academies in the sixteenth century to the present time, the study of the nude has been recognized as an effective means of developing coordination of eye, brain and hand. The prospectuses of some art schools now give the impression that they are offering training courses for social workers, but I feel there can be no substitution for the life class in the education of an artist. It has become a traditional part of the student's experience and is still valid even if he intends to design bridges.

Wyatt Eaton was in Paris by 1873 and studied at the Ecole des Beaux-Arts under Gérôme. His *Eve* (Pl 11), painted in 1879, is the earliest example in this selection of the work of artists trained in Paris. The title of the picture seems strangely incongruous, with the lady looking as though she might be resting after taking part in Delacroix's *Death of Sardanapalus*. It is a purely romantic painting. (Throughout art history, of course, the titles *Eve, Venus, Aphrodite* and others have been interchangeable in naming nudes. All alike pay homage to the beauty of women. The same sentiment applies to paintings of beautiful young male figures under such titles as *Perseus, David* or *Mercury.*)

Another of the early arrivals in Paris was William Brym-

ner, who came in 1878. He attended Julian's and studied under Carolus-Duran. His *Reclining Figure* (Pl 13) is a straightforward piece of painting revealing the artist's delight in rendering flesh in paint. It does not seek to hide its nakedness under the cloak of some classical or allegorical title.

Soon to follow were Blair Bruce and Paul Peel. In Bruce's *La Joie des Néréïdes* (Pl 12), the introduction of figures with an unmistakable *fin-de-siècle* presence into a mythological context gives the picture an equivocal flavour with strong overtones of Symbolism. Paul Peel, who had displayed an extraordinary youthful virtuosity, studied at the Ecole des Beaux-Arts under Gérôme and spent much of his short life in Paris. His painting *The Little Shepherdess* (Pl 14) suggests an admiration for the voluptuous nudes of Correggio, which indeed affected nearly all academic handling of the subject. It is possible that the original title of this painting was *Daphnæ*, which would give it the desired classical context.

If Peel was the first Canadian artist to attempt to establish a pattern of living abroad and returning to Canada to sell, he was the first to fail. At an auction of his work in Toronto in 1890, sixty of his canvases earned him about $2000. The top price paid was $325 for *The Venetian Bather*, which had been exhibited at the Paris Salon and is now in the collection of the National Gallery of Canada. Peel returned to Paris, where he died two years later of tuberculosis at the age of thirty-one.

Franklin Brownell's *The Golden Age* (Pl 15) and F. S. Challener's *Aphrodite's Realm* (Pl 17) are further examples of license to portray nudes in mythical scenarios. Such paintings were even more acceptable if they were part of a decorative ensemble sanctioned by long tradition. For example, no fault was found with nudes sporting on a ceiling, or in panels which were an integral part of the luxurious decor of a theatre or the lounges of steamships. Challener was able to promote for himself several commissions of this nature, of which *Roundel, Dusk* from the Russell Theatre, Ottawa (Pl 16) is a charming example. Joseph-Charles Franchère's *Sylphide* (Pl 18) carries the convention to the ultimate of *coquetterie*, reducing the flesh in the process to a synthetic covering for a mannequin.

After Impressionism

The first Impressionist exhibition was held in 1874, and although its implications were not immediately apparent, they heralded the recognition of the autonomy of the work of art and the subordination of all other considerations to the form and the expression of the artist's statement. In Canada its

influence was slow to take effect and was most visible in the brighter palette adopted by the landscape painters, in particular Suzor-Coté and Maurice Cullen.

Aurèle de Foy Suzor-Coté entered the Académie Julian in 1890, the same year that James Wilson Morrice arrived in Paris. Although he submitted to the usual academic training, it was finally the influence of Impressionism which Suzor-Coté brought back to Canada in 1908. However, his *Symphonie Pathétique* of 1925 (Pl 19) shows how persistent were the sentiments of nineteenth-century romanticism. It recalls the Byronic cult of passion and sensibility, the fashionable despair of Goethe's *Werther* and the symphonic violence of Wagner's music.

Among the new freedoms opened up to all artists by the Impressionists were a more arbitrary use of colour and a more sensuous or painterly handling of the oil medium. The greatest Canadian exemplar of this refreshing release was James Wilson Morrice. Paris was his headquarters and his spiritual homeland after 1890. Over the years his wide acquaintanceship there included members of the American realist group called The Eight, the English artists Beardsley and Sickert, the critic Clive Bell, the Irishman Roderic O'Connor and the Australian Condor, who became a close friend. He knew most of the leading French painters of his time and painted for two winters in Tangiers with Matisse. He impressed Somerset Maugham and Arnold Bennett strongly enough for both authors to characterize him in novels, and he was even mentioned with admiration by the notorious practitioner of "Magik", Aleister Crowley, despite the latter's assessment of Canada in 1905 as "a loveless, lifeless land."[4]

As a painter, Morrice followed no theory and was subject only to the influences of artists whose work he admired, especially Whistler, the Nabis and Matisse (particularly in his later figure paintings). He could best be described as a practitioner of *la belle peinture* and, as such, had a great effect on the work of younger Canadian artists. The bases of his art can be seen in the beautiful *Nude Study* (Pl 2). Notice the figured background with the Japanese motif, the atmosphere of intimacy and the sumptuousness of the painting.

Morrice maintained relations with fellow Canadians such as Cullen, Brymner and Gagnon and returned regularly to Canada until the First World War. John Lyman, who met him in Paris in 1908, wrote of Morrice's reception in Canada: "That our country persisted in misunderstanding him despite the distinction rendered him in the artistic capital of the world disappointed him more and more as the years went by".[5] Lyman had earlier remarked that in the Morrice Retrospective of 1937 not a single example of his paintings of the

nude had been included because none was owned in Canada at that time. He commented, "One wonders why the human body is in such disgrace among us".[6]

Another admirer of Morrice was John Russell, whose work is too little known in Canada. He was in Paris by 1906 and lived there for more than twenty years. He finally settled in Toronto where he opened a studio in 1932. Russell was thought to be upstaging his fellow countrymen by painting European scenes, and his nudes were received with vociferous horror. His *Nude Resting* (Pl 20) calls to mind Manet's *Olympia* seen from the rear and with the doll taking the place of Manet's maid.

In 1908 John Lyman entered the Académie Julian and a year later studied under Henri Matisse, along with the English painter Matthew Smith, with whom he retained a close friendship for many years. For Lyman, the Matisse influence was decisive and he went on to develop his own highly individual form of Fauvism. His *Nu citrine* (Pl 22), with its emphatic rhythmic drawing and simplified colour areas, shows this influence very clearly. I have also included his painting *Trouble* (Pl 21) as an example of expressionism used to convey serious human concern, in contrast to the trivial or sentimental narratives which used to infest academy exhibitions.

Lyman's first one-man show at the Montreal Art Association in 1913 challenged the critics to dredge for new depths of abuse, and Lyman did not return permanently to Canada until 1931. From that time, his services to Canadian art were many. In 1938 he founded the Groupe de l'Est as an exhibiting body, and in 1939 the Contemporary Art Society. His articles, many of them in *The Montrealer*, did much to open up a more cosmopolitan outlook. In 1932 he gave Goodridge Roberts his first critical recognition.

Goodridge Roberts said that the first good exhibition he saw was the Morrice Retrospective of 1924 in his first year at the Beaux-Arts in Montreal. Roberts became one of Canada's greatest landscape painters. Like Cézanne he rigorously pursued his sensations before nature, translating his responses to aspects of nature into formal terms.

His figure paintings were derived from Matisse as can be seen in the piquant *Nu debout* (Pl 23). Later, he painted in a more expressionistic manner and his colour became more strident. His *Reclining Nude* of 1961 (Pl 1) is reminiscent of the paintings of Matisse's pupil Matthew Smith, whose work was known in Montreal through the Contemporary Art Society, of which Roberts was a charter member.

Goodridge Roberts was the least articulate of teachers, but younger artists such as Jacques de Tonnancour and John Fox learned from him. De Tonnancour's fine early *Le grand nu au*

divan rouge (Pl 25) shows this influence. He later developed a highly original landscape style and is now a non-objective painter.

Stanley Cosgrove was also affected by Roberts, but in his development he turned in the direction of Classicism rather than Expressionism, as one can see in *Anne* (Pl 24). His paintings, both figure and landscape, are similar to the later works of André Derain, which aimed at a type of realism tempered by the Cubist experience.

A contemporary painting by John Fox of Montreal shows a continuing concern for the painterly touch in the Morrice manner. Fox's *Model at Mirror* (Pl 26) of 1970 is in the *intimiste* tradition of the interior scenes favoured by the Nabis, particularly Bonnard and Vuillard. It is also a modern example of the pre-Cubist convention of revealing two aspects of a figure by the use of a mirror.

Contemporaries of the Group of Seven

The 1920s saw the rise to fame of the Group of Seven. As Lyman pointed out in an article in *The Montrealer* in 1940, "Once the movement caught on with Canadian sentiment, it was, as could be expected, more its Canadianism than its artistic values that gave it popularity". Nevertheless, the Group produced some of the finest landscapes ever painted in Canada.

In their best period, when the excitement of their discoveries was still fresh, the members of the Group were infected by intoxication with paint, and their style reflected Northern Expressionism, with a liberal flavouring of Art Nouveau. They penetrated areas of the country not yet recorded by artists, with a sense of mission which left little room for interest in the human figure. Of course, much of the country they explored was not only uninhabited, but devoid of historical relationship with Europe. D. H. Lawrence has remarked in his *Studies in Classic American Literature* that he felt the alien and even hostile aura of the American land. Its history was Indian, and it was their people who endowed it with the animistic attributes so eloquently depicted in the paintings of Emily Carr.

Among the original members of the Group, only Frederick Varley was an uninhibited sensualist, and this proved to be a source of strength which extended his range beyond that of his colleagues. When, for instance, he was driven by necessity or whim to paint a portrait, he did it better than any Canadian before or since.

Although no more than thirty years separates Varley's

Nude on a Couch (Pl 27) from the Morrice (Pl 2), they are a century apart in feeling. Varley's picture has the Northern look; Morrice's the Mediterranean. Varley's paint surface is disturbed, the background a turbulent Canadian landscape; his lines swirl, he uses the technique, first fully exploited by Degas from photography, of cutting off his subject by the frame to give it a more vivid immediacy.

While Lawren Harris, who was a Theosophist, turned to abstraction about 1936 in an attempt to represent "the cleanliness of the psychic atmosphere of Canada",[7] Varley in his later years devoted himself more than ever to its human inhabitants. His drawing *Nude with Apple* (Pl 28) has a tender beauty.

In a totally different vein from the style of the Group of Seven were the paintings of LeMoine FitzGerald, who was admitted to the Group just before it disbanded. In his landscapes, cityscapes and still-lifes he strove for a formal order based on Cézanne. Later, he turned to nudes in pursuit of his search for monumental forms. He hung one of these over the mantel until a neighbour complained that her children could see it through the window. In this unfriendly environment it is not surprising that he did not exhibit his figure paintings and, late in life, produced a large number of studies and drawings which he showed to no one.

The *Nude in an Interior* (Pl 3) is an unfinished oil painting, one of a group found in the attic of the old FitzGerald house in Winnipeg in 1964. It is closely related to his drawings and shows how carefully he built up his forms, cautiously advancing the surrounding space to their defining edges, like a quiet tide on a sandy shore. As this painting shows, he often used a pointillist technique like that of Seurat.

FitzGerald's nudes are some of the most impressive ever produced in Canada, but they were fated to obscurity. Only two drawings of the nude were included in his retrospective exhibition of 1958. Even today, I know of several of his best paintings of the nude which may not be shown because of their owner's Victorian sense of propriety.

The figure painters of the 1920s and 1930s in Canada were the second generation under French influence but they were also aware of the work of the American realist group, The Eight. Randolph Hewton and Edwin Holgate both studied with Brymner in Montreal and in Paris at Julian's. Hewton's *Sleeping Woman* (Pl 30) and Holgate's *The Bathers* (Pl 29) show an increasing trend towards realism. This becomes evident when one compares the background of the Holgate with the Brownell (Pl 15), for example. While Brownell still uses the landscape of legend, Holgate, who became a member of

the Group of Seven in 1931, employs a typical Canadian scene. In many of his paintings he has combined the nude with landscape more lyrically than any other Canadian artist.

A more direct influence of the American realists was evident later in the figures of Philip Surrey, who studied at the Art Students' League in New York. A friend of John Lyman, Surrey exhibited with the Groupe de l'Est. His *Nude Men wading into the Sea* (Pl 33) is one of several sketches he made of this subject. He is best known as a recorder of life in the streets of Montreal, and his *Study for Place Ville Marie* (Pl 32) recalls the lusty New York scenes of Reginald Marsh.

Prudence Heward studied with both Brymner and Hewton. Although her *Girl under a Tree* (Pl 34) shows superficial traces of Cubism in the background and the distorted planes of the face, its most interesting characteristic is the feeling of psychological malaise, possibly a reflection of the troubled period of depression and social upheaval of the 1930s. Here the feeling is conveyed without the aid of narrative suggested in Lyman's *Trouble* (Pl 21).

The Depression threatened the existence of an artistic aristocracy of sorts which, during the previous decade, had established itself for the first time in Canada. It consisted of artists, writers and musicians who felt themselves to be an élite. Their patrons and associates were for the most part professional people, and although few of them could be called well-off, most had enough to support a tolerable existence. They gathered at one another's homes and in such social centres as The Arts and Letters Club in Toronto. They pursued a kind of exalted bohemian way of life, not unlike that of the inhabitants of Bloomsbury.

The work of these artists of the 1920s and 1930s has so far been largely neglected by art historians, probably because their reputations have been obscured by the fame of the Group of Seven. The present whereabouts of the majority of their paintings has not been investigated or established, but it is certain that many of them painted from the nude as part of the studio tradition.

The most respected portrait painter of this establishment was Lilias Torrance Newton, who painted many of the most distinguished people of her time. Lawren Harris, who hated to have his photograph taken, always tried to fend off requests by offering the Newton portrait of himself as a substitute. Her *Nude in the Studio* (Pl 31) gives an immediate impression of the intense vitality and vibrant presence of the subject. Then one is intrigued by the composition with its narrow format, and the way the head of the model obscures the portrait head on the easel. It is our first example of a nude in which the

artist records a personality rather than an anonymous figure.

The *Figure Study* (Pl 36) by Will Ogilvie is an excellent example of a style that was pervasive between the wars, now known as Art Deco. Its characteristics are not easy to define, but perhaps it could best be described as "tasteful modern". The arabesques of Art Nouveau were combined with the geometry of abstract art and applied to architecture and to every kind of product, whether custom-made or industrial. The exotic face of Ogilvie's nude, the tubular forms of her figure (recalling Leger) and the decorative folds of her robe are typical of the style.

Up to this point the Canadian art world had remained an enclave into which outside influences penetrated slowly and, for the most part, somewhat superficially. Some artists went to Europe or New York to study, and those who stayed home read *The Studio* and other art publications. As we have seen, the post-Impressionists, Fauves, Expressionists and American Realists had modified the outward form of Canadian painting, but few signs had yet appeared of a radical change in content.

Bertram Brooker (nicknamed Little Kandinsky) had essayed his first non-objective paintings about 1925 but soon abandoned them. Lawren Harris did not begin his until ten years later. Fritz Brandtner came to Canada from Danzig in 1928 and brought news of the Bauhaus in Germany. While Cubist images, inspired by Picasso, occasionally appeared, the full implications of the two great turning movements of the twentieth century, Cubism and Surrealism, were not yet realized, and remained the subject of discussion in the schools and studios. But the ferment was stirring and finally surfaced in the 1940s.

New Directions

The return of Alfred Pellan to Montreal in 1940 was a significant event in the history of modern art in Canada. Pellan had been in Paris since 1925 and had a profound experience of European art. He brought back with him enough canvases for a large exhibition which made a stunning impression. Pellan's art acknowledges a debt to Picasso and to the shallow space of Cubism, but it was Surrealism which claimed his final allegiance. His *Sur la plage* (Pl 4), painted about 1945, demonstrates how he suggests depth by two-dimensional means, and also his relationship to artists such as André Masson and Miró, both of whom he admired. It also shows his intense vitality, based on vibrant colour and powerful imagery. It is easy to believe that such canvases must have galvanized the younger artists of Quebec.

In 1943 Pellan started to teach at the Beaux-Arts in Montreal. At the end of his first year, two of his students had paintings removed by the authorities from a show of school work. One of these was a nude showing pubic hair, which, at Pellan's ironic suggestion, was then provided with bathing shorts. A riot followed.

Among those stimulated by Pellan was Paul-Emile Borduas, author of the revolutionary manifesto *Refus global* of 1948. In other parts of the country, influential teachers such as Jock MacDonald in Toronto and Jack Shadbolt in Vancouver opened up new vistas on the international scene, which led to today's proliferation of styles. If there is one characteristic predominent in twentieth-century art, it is diversity. The relatively uncomplicated problem of selecting a subject and rendering it in a manner combining period style with personal idiosyncracy is no longer the major concern.

For a while, Cubism provided a new way to paint, and Surrealism extended the range of what to paint, but both roads pointed inexorably towards non-objective art. There are those who have chosen to regard this direction as the mainstream of contemporary art and to disregard all else. However, it should be remembered that within one decade of its origin before the First World War, the pioneers had already suggested the limits of non-objective art — Kandinsky the expressive, Kupka the lyric, Malevich the geometric, and Mondrian the metaphysical. Subsequent developments such as Automatism, Abstract Expressionism, Colour Field, Optical and the new Lyrical Abstraction are further explorations based on their discoveries. But figurative art has also continued to develop and produce new images. It seems to me that once the mainstream concept has been set aside, we can recognize that contemporary art is a rich delta with unlimited possibilities for cultivation.

While the nude is now rarely the subject of a painting, it is often an important part of the content. In the survey which follows there is no intention to type artists, but only to discuss individual works under certain chosen categories.

After Cubism

Bertram Brooker was a man of many interests who taught himself to paint about 1924. His first pictures were non-objective, an attempt as he said, "to paint verbs — or movements — activity".[8] He soon retreated from this advanced position, and most of the paintings which followed range between realism and varying degrees of abstraction based on natural forms. His *Kneeling Nude* (Pl 5) of about 1940 owes an ob-

vious debt to Cubism and Futurism. The abstract planes in the sky are close to the forms used by Lawren Harris and LeMoine FitzGerald in their late non-objective works. He was at one time associated with each of these men.

Earlier, Brooker's more realistic nudes had embroiled him in public debate. On one occasion in 1931, his painting *Figures in a Landscape*, after being accepted by the artists' jury of the Ontario Society of Artists for their annual exhibition at the Art Gallery of Toronto, was removed from the walls by a gallery official on the grounds that it would be found objectionable for viewing by school children. The matter was aired, inconclusively, in the newspapers, and the painting was crated and shipped off to Montreal, where it was hung (without protest) in the Spring Show of 1931. Brooker's *Eve* (Pl 35), a design for the title page of a book which was never published, illustrates his use of voluptuous forms.

Michael Snow's *Seated Nude* (Pl 37), with its superimposed planes and lack of depth, also betrays a debt to Cubism (especially collage), but its suggestion of movement indicates the future course his work was to take. His *Walking Woman* series, in which the figure symbol was used as a module to explore differing aspects of reality, was paralleled by his increasing use of the camera to achieve the same end.

Continuing Expressionism

The expression of intense feeling by violent technique was exemplified in this century by the Fauves and Expressionists. It has continued to mould much figurative art. We have already noted the development in Goodridge Roberts' later paintings.

The most direct Canadian descendant of the Expressionists is Bruno Bobak, whose paintings always record human relationships with deep compassion. His *Nude with Black Stockings* (Pl 38) reminds one of Edvard Munch's fascination with alienation deriving from fear, loneliness or sickness.

In a more gentle vein, the figures of Peter Harris convey the same sense of isolation. *In Repose* (Pl 39) is a recent example of his sensitive nude-studies.

The paintings of Graham Coughtry are expressionistic in handling and form, but they are primarily concerned with the integration of the figure into the total picture space, evoking an environment as well as a presence. They could be described as human landscapes providing a poignant comment on our destiny. As in *Two Figures #5* (Pl 8), most of them depict a relationship of two figures.

Robert Markle's figure paintings are rich and dark and the most deeply sensual among Canadian nudes. His *Drawing for*

Pale Blue Marlene #3 (Pl 40) recalls the sentiment of Baudelaire's poem *Les Fleurs du Mal*:

"Comme de longs échos qui de loin se confondent
 Dans une ténébreuse et profonde unité . . ."

Markle painted a series on strippers, indicating an interest in burlesque shared by many artists. Maybe they recognize in the performers practitioners of another art or ritual. But the erotic nudity permitted on the Yonge-Street Strip in Toronto is still not generally welcomed as a subject for painting.

The circle has always been featured in the non-objective paintings and sculptures of Gerald Gladstone. This propensity may have led him subconsciously to the curvaceous series of paintings of 1969, titled *Downtown Nudes* (Pl 42). He himself says, "A galaxy of secretaries follow her up Yonge Street in echoing image paths which led me to the series of paintings."[9] They could be likened to automatic drawings and are close to the early works of Americans such as Pollock and Gorky, in which themes and techniques of the Surrealists were used in their progress towards the development of Abstract Expressionism. Gladstone's painting has a sense of light, air and movement and a voluptuousness of form suited to the subject. It looks as though it might be the vital inner core of a Baroque painting.

Robert Hedrick has described his art as being directed towards a synthesis of the emotional and the analytical. This has been more apparent in his sculpture than in his painting, which, for the last five years, has explored harmonic order in colour. However, on his return from Spain in 1964 he produced a brief series of nudes. *Homage to Goya* (Pl 41), in which this synthesis is triumphantly achieved, is the finest of these.

Mashel Teitelbaum's *Startled Woman* (Pl 43) is an example of what is usually termed *art brut*, or brutal art, in which a kind of savage force is used, in the words of Dubuffet "to render such a presence more powerful, more impressive, more astonishing".

Some contemporary artists have felt constrained by the edge defining the limit of their canvas and by its surface. (For example in 1961 Harold Town painted a series of large works titled *Tyranny of the Corner*; others have tried shaped canvases.) In his recent series, which includes *Startled Woman*, Teitelbaum has found his own solution by pouring acrylic paint on a floor covered with a plastic sheet. As the paint dries he manipulates the resulting skin into the desired form and finally lifts it off the sheet and attaches it to a conventional canvas, which then becomes a backing for the work rather than a ground.

After Surrealism

As stated earlier, Surrealism extended the content of figurative painting, but it did not dictate its form; therefore, its exponents have used styles varying from the most expressionistic to magic realism.

The dreamlike quality of Louis de Niverville's *Morning* (Pl 6) is typical of many Surrealist works. The nudes in this painting are participants in some drama, unexplained but intense. The introduction of the exterior landscape by means of a mirror instead of the conventional window preserves the almost claustrophobic atmosphere of the room, despite the wind which blows through it.

The earlier paintings of Ivan Eyre were inhabited by figures, seemingly victims in a desolate prairie landscape cluttered with still-life objects. In his recent work, the forms, now paper-thin, are deployed in illusive space. The landscapes still echo some disaster, but the figures have become ghosts from the past. *Stills: Willows* (Pl 44) of 1970 seems to record some unknown ritual, the willow trees a sign of hope and new life.

Jan Menses' *Klippoth Series* (Pl 45) is one of a very long sustained set. He explains that in the Jewish kabbalistic system, the klippoth form ten sefiroth, or degrees, where darkness and impurity thicken progressively as in the circles of Dante. Even without this explanation, the sense of Kafkaesque terror, and confinement of the figures in an alien environment, is very evident.

I have included Alex Colville's *Nudes on the Shore* (Pl 49) here although it might be called a magic-realist painting. However, for me, the scene has the strong evocative quality of a dream, and the Ingres-like figures suggest that they are really one person in self-contemplation.

Metaphors and Symbols

Artists seeking to express meaning beyond form often follow the poets in using metaphors and symbols. In her *Bilboquet II* (Pl 46) Michele Bastin alludes to the ancient courtly game of cup and ball to emphasize metaphorically the roundness of breasts. Instead of singing with Solomon "thy breasts are like clusters of grapes", she likens them to cuppable spheres. Both the ball and the breast are shown, as well as the metamorphosis of the one into the other. Thus, a poetic metaphor is rendered in visible form.

When the poet declares "I see a lily on thy brow" or "her neck is like a swan" a subliminal image is raised in our con-

sciousness of the object he is using for his comparison. In the same way, Sorel Etrog's *Study After Ingres' Turkish Bath* (Pl 48) evokes an instant recall of this familiar masterpiece. To this extent, Etrog's painting might be called metaphoric, despite the fact that its meaning is totally different from that of the Ingres picture. As in his sculpture of recent years, Etrog seems to be calling attention to the inter-dependence of human beings by linking them together mechanically. Nevertheless, our memory of the Ingres adds depth to our enjoyment of the Etrog. Here, as in many literary metaphors, an element of wit is involved.

Esther Warkov does not intend us to decipher the symbols in her *East of Alabama* (Pl 47) to arrive at any exact meaning. However, in her assembly of images of black figures, flowers, fruit, moth and television set, she succeeds in introducing a touching element of tenderness and beauty into an environment we have come to regard as characterized by terror and inhumanity. This again is a visual poem.

New Realists

Realism is an attitude rather than a technique and can best be described as the opposite of the ideal. The American Realists I mentioned earlier were sometimes called The Ashcan School because of their deliberate choice of down-to-earth subject matter. A recent example of this kind of realism is *The Letter* (Pl 50) by T. R. MacDonald. His technique is academic, but the inelegant pose of the model and the kitchen-type furniture convey the impression of a casual, unrehearsed scene.

However, most contemporary artists use a technique, sometimes referred to as magic- or super-realism, to concentrate attention on their subject and hence increase its evocative power. In order not to emphasize the pigment itself, they often use tempera or acrylic rather than oil paint.

Eric Freifeld places his model *Pauline* (Pl 51) in a total environment so explicit as to suggest that we are observers of a real person at a specific moment of time, yet it summons all the past which has moulded her present. Hugh Mackenzie's *Girl in a Fencing Mask* (Pl 52), despite its meticulous technique, is less real than the Freifeld. The girl's body is tenderly painted and lovingly presented, but the mask withholds total exposure and suggests an intriguing mystery. There is always an element of poetry in this kind of painting.

Portrait (Pl 53) by John Leonard is an excellent example of uncompromising representation of a personality. We are arrested by her immediate presence and only later become aware of the means by which the artist has achieved his effect.

After Pop Art

Pop Art was a movement of great importance, seeming inevitable and timely. It avoided the problem of period style by eliminating style – it did not present an object in a manner, but presented the object itself, or its image in close facsimile, or a ready-made popular symbol. Its deliberate vulgarity was closer in spirit to Leger's late work than to that of the Dadaists with which it has often been related. In spite of themselves, the work of the Pop artists acquired a sense of style that will soon be as fixed in time as the Art Nouveau phenomenon of the turn of the century.

In revulsion from anguished self-examination and expressionist urgency, Pop Art accompanied the emergence of the minimal in painting and sculpture. The minimal sculptor may be suggesting, "Rodin could lie to you. I don't – there it is!" And there indeed is his simple form, occupying a finite space, subject to gravity and radiating objectivity. These sculptors deliberately eschew the relations and formal hierarchy inherent in the human figure and thereby declare the nude by its very absence. It is said that inside every fat man lurks a thin one: perhaps inside every pristine rectangle is curled up a sensuous nude. Clyde McConnell's intriguing drawing (Pl 54) seems to suggest it. This drawing is an example of the ambition of many artists to integrate the abstract with the figurative – a task as fascinating as the pursuit of a theory of human proportion in the investigations of Vitruvius, Leonardo da Vinci, Dürer and Hogarth.

The Pop artist also confronted us with a relatively simple statement, a slice of life, and invited us to examine it out of normal context. Much of the figurative painting which followed was influenced by the movement.

The symbolic nude, as graphic as a traffic sign, in Greg Curnoe's *Spring on the Ridgeway* (Pl 56) derives from Pop Art, as does the introduction of real objects such as rayon curtains, metal window lifts and so on. The lettering bordering parts of the frame may also be regarded as an instant form of communication which Curnoe carried to the ultimate in later works where the lettering took over the whole ground and images were eliminated.

The figure in Dennis Burton's arresting *Niagara Rainbow Honeymoon #1 The Bedroom* (Pl 57) is a packaged nude, and a reminder that Pop Art was very much involved with containers. Other Pop features are the inclusion of a cliché image (the famous Falls) and mocking reference to another art style (Op Art) in the squared rainbow.

James Spencer's *Margaret* (Pl 58), although superficially similar to the Burton, is in fact quite different. Here the artist

has elected to copy with exactitude an existing image, a picture from a girlie magazine, which is as legitimate a subject as Roy Lichtenstein's cartoons. The question of plagiarism was raised in connection with the Lichtenstein paintings copied from newspaper comic strips. However, as was pointed out at the time, the nature of the message had been radically changed by transforming the medium and the scale. For example, the Benday dots used as a tonal value in the strip became a beautiful component of the space in the paintings. Spencer uses ready-made subject matter to raise questions about the relationship between the fundamental nature of the subject (in this case a photograph) and the object (the painting). The ambiguity is deepened by the over-life-size scale of the painting, which also brings into consideration the reality of the model herself.

Tom Hodgson, as a member of Painters Eleven in the 1950s, was an Abstract Expressionist. He now concentrates on portraits in a refreshing movie-ad style, with echoes of his earlier painting in the backgrounds. In his *Maria #1* (Pl 59) he uses the film device of a double image.

Although the journeyman portrait painter finds it hard to compete with photography, a few people still commission portraits. Many great paintings of the past are portraits and it would be a pity if the genre were to lapse altogether. Hodgson's nude portraits in Toronto (and those of Elwyn Chamberlain in New York) are not without historical precedent, going back much earlier than Napoleon's sister Pauline, who took off her clothes with such complacency.

Social Comment

Although Claude Breeze deplores the suggestion that he is a social commentator, particularly in any political sense, his deep concern with human behaviour has been obvious in most of his work. Nudes in his *Lovers in a Landscape* series were presented in a continuing sexual drama, savage and satirical. They had the effect of attacking the pretensions of tame and sanitized erotic art. In this series, *Mandala* (Pl 7), with its echoes of Bonnard, Matisse and Ensor, demonstrates his love of painting and his great abilities as a colourist.

John Boyle's paintings contain an element of satire, but they appear to be based on records of his favourite places, with the addition of hero figures. The real-life characters which inhabit *Ontario Street* (Pl 63) induce speculation about the place and its history. There appear Gabriel Dumont (Louis Riel's General) and portraits of a local sports star, a writer and a musician. The nude, with the head of anarchist

Emma Goldman on an alien body, seems to regard it all with insouciance. In *Lakeside Park* (Pl 62), Lenin is represented with another anarchist Louise Michel. Despite the appearance of all these revolutionary characters, Boyle's paintings are anything but inflammatory. I think that he introduces nudes to remind us that clothes tend to become uniforms which can obscure the basic humanity of his heroes.

The Camera

Since its invention, the camera has provided the artist with a third eye, offering fresh vision. Photography can freeze movement, record a passing event, simplify or dramatize tone through light, juggle scale, explore textures and change focal perception of space. Photography not only helped artists to dispose their subjects (as in Vuillard's interiors), it also guided them to a new intuitive grasp of the appearance of reality (as in the remarkable racecourse paintings of Degas). Above all, it freed picture space from the shackles of Renaissance perspective. For centuries artists had used aids such as the camera obscura to assist them in dealing with the complicated requirements of mathematical perspective dictated by a single viewpoint. The camera, with its distorting effects and exaggerated foreshortening, suggested a new freedom of spacial order. The placement of the figure in the Varley painting (Pl 27) would have been inconceivable before the invention of the camera.

Two other obvious examples of the direct influence of photography are Spencer's *Margaret* (Pl 58), in which the artist has allowed the camera to dictate the disposition of light and dark areas; and the McConnell drawing (Pl 54), which suggests the graphic quality of photographic prints.

Film

Film, on the other hand, has created a world which is parallel to life, sometimes larger than life, with its own reality, poetry, drama and mystery — a world which has been very suggestive to artists. Many have become film-makers themselves. Filmstrip technique has been used by several Canadian artists (notably Michael Snow and Joyce Wieland), and Warren Peterson's drawing (Pl 55) shows the use of a multiple image. Here again is evidence of an experimental approach to containing a figure in a geometric form.

John Gould's drawing *Ancestors #1* (Pl 60) relates to film in a more obvious way. He has previously animated his draw-

ings and extended their range by filming them. As a feedback from this experience, his recent experiments have been directed to simulating the movement, multiple perspective and focus of film in the drawing itself.

Early Surrealist films made in Paris in the 1920s were considerably influenced by painters. An example is *Le Chien Andalou* of 1929 by Dali and Brunuel. Richard Turner's *Initiates of the All Over* (Pl 61) suggests a return influence of Surrealist film on painting. This cross-fertilization of ideas between media can also be seen in Pop Art, which created a new style for advertising visuals after being to a great extent derived from them originally.

Light Art

Light artists have employed their medium in ways as various in expression as those of the painters. The range, from the minimal-environmental works of Dan Flavin to the theatrical kinetics of Intersystems, is wide, and includes Op Art, viewer participation, and surrealistic space-time constructions.

Audrey Capel Doray's works of the late 1960s carried a message of social protest, always latent in Pop Art. *Rebirth of Venus* (Pl 64), from the satirical Venus series,[10] was programmed to pulsating light-sequences synchronized to music with a strong rhythmic beat. When turned on, these works command instant attention.

Conceptual Art

There are conceptual artists who perform a jester's role in our society. In mediaeval times, the court jester was permitted extreme licence to ignore the proprieties and thus relieve the burden of false values (such as the privilege of holding the royal shirt at the levée) by recalling the existence of more natural ones. Today, we permit artists to plow furrows over miles of land, dig holes, hang bicycles in trees, or wrap up large areas of coastline in polyethylene. In these and a hundred other ways, the conceptual artist tries to alter our perceptions, question our values and expand our consciousness of time, space and reality. For instance, wrapping up a large chunk of the earth may suggest metaphorically our new awareness of the planet's size, illuminated as never before by space exploration.

In this spirit Michael Morris produced a series of stills in

connection with the National Film Board's exhibition *B. C. Almanac(h) C-B*, in 1970. They were later published[11] as *Studies for Drawings to be Filmed* (Pl 65). In these, nudes were shown illuminating each other's bodies with sunlight reflected by means of a mirror. As Morris explains in a letter, "The nudes are not the subject of the pictures; they are performers illustrating the activity of drawing as an extension of the sense of touch; this is easier to understand on film than from a couple of photos." In such a context the nude can only appear as the naked. One notices that the naked figure lacks dignity when compared with the nude in art, perhaps because the artist interposes himself between the model and the viewer.

Drawing

Ingres called drawing "the probity of art". Matisse wrote, "It is not possible to separate drawing from colour. Since colour is not applied haphazardly, from the moment there are demarcations and proportions there is a division. And it is precisely here that the artist's creative power and personality intervene."[12]

These two statements could lead to a wider and deeper definition of drawing than that commonly held or even that suggested by Michael Morris. Ingres was saying that drawing is the foundation, the innermost structure on which a work of art is built. The moral implication is that if the concept is not pure the result will be impure. Matisse was suggesting that drawing is an integral part of painting and, indeed, the vehicle through which the artist's intention is translated into form.

Carrying these concepts further, we might arrive at the idea that drawing is present in all works of art, even when it is not apparent. Matisse also wrote, "When you know an object completely, you can encircle it with an outside line that defines it entirely." To the non-objective artist, that line is in the mind's eye and his vision is expressed in terms of defining its limits in space. Every plane or field has its edge and, as Blake said, "Nature has no Outline but imagination has."

Drawings are often used by artists to work out ideas. In his *Study for Place Ville Marie* (Pl 32), Surrey decided the arrangement of the figures in the same way a choreographer designs a ballet. They were, of course, clothed in the oil painting which followed. The Peterson drawing (Pl 55) is also an exploratory work in which he is testing formal problems, but it is not intended as preparation for a particular work in another medium. The placement on the page is evidence that

Peterson visualized it from the beginning as a work of art in its own right. McConnell's drawing (Pl 54) is also a completed work, conceived and executed for the medium. Although Gould's series under the generic title *Ancestors* (Pl 60) is experimental, each work must be regarded as a total composition.

Jack Shadbolt writes of his drawing *Female Nude* (Pl 66), painted in 1940, noting ". . . the voluptuous rhythms: the languor of the turning forms, the continuous extension of the sensuous volume undulations in the fulness of their sculptural presence, the eloquence of the contour lines: the negative spaces."[13] This is the language of a draughtsman who has, however, brought the same considerations to painting.

Louis Muhlstock is one of the generation whose art was formed in Montreal in the 1940s. Like Stanley Cosgrove, he tended towards neo-classicism. His *Reclining Nude* (Pl 67) is one of a long series of drawings of the female nude, on which his reputation mainly rests.

Christopher Pratt is a realist whose drawings differ from his paintings only in medium. His *Donna* (Pl 69) has the appearance of a careful drawing from a plaster cast, with a difference: no student ever brought to the study of a cast the love which Pratt has expended on his drawing. The planes of the body are caressingly described and slightly formalized to suggest the stillness of marble: in fact the feet have the appearance of a base.

Harold Town is one of the world's most prolific draughtsmen.[14] Among Canadians, only he has tested all the expressive possibilities of the nude suggested by Kenneth Clark in *The Nude*. In his drawings he has presented the nude in strife, love and anguish, and in every kind of social condition, both mythical and topical; yet his paintings are non-objective. This might lead to the expectation of some artistic conflict of interest; not, however, if the wider definition of drawing is accepted. In fact, his *Seated Nude* (Pl 72) has the attributes of a painter's drawing. The figure appears to have been opened up and splayed to accommodate the surface of the page. The flatness of the back is accentuated by the painterly strokes of the charcoal; the outlines are forcefully defined as if with a brush. It is a masterly statement of sculptural qualities in two dimensions, and at the same time an expressive drawing.

Etrog's *Study after Ingres' Turkish Bath* (Pl 48) is an exercise of intelligent wit almost equivalent to a literary pun. *Lovers* (Pl 70) by Joyce Wieland, one of a series of drawings done in 1961, displays wit of a different order. Wieland has always worked in a humourous vein which does not conceal her very sympathetic feelings about the antics of people. This

lively drawing is linked to her paintings, in which surprising transformations occur and sexual organs change into hearts and flowers.

At the beginning of this essay I mentioned two kinds of primitives; the one who strives for professionalism, and the other who ignores it. Sindon Gécin belongs to the second category. His naive technique seems to suit the innocence of his *Adam and Eve* (Pl 71). He is a retired schoolmaster who started with a book entitled *How to Paint*. He tried several media but finally settled on pen and ink. He says, "I feel that I have embarked upon a marvellous and magic adventure which makes life really worth living – a state of happiness one would like to continue forever."[15]

Conclusion

If until very recently the Canadian art climate has remained hostile to painters of the nude, the same can be said of that of the United States, where in the early nineteenth century the nudes of John Vanderlyn[16] were as shocking to Americans as those of Paul Peel were later to Canadians. The reason is not hard to find.

The morality of the inhabitants of this continent crystallized during the Victorian age, when the greatest expansion of its social structure took place. That morality was based on the maintenance of an appearance of respectability. It is not necessary to enumerate all the blue laws which sought to preserve an essentially puritanical ethos devoid of charity. As late as 1942, Wyndham Lewis, writing to John Rothenstein, referred to Toronto as a metropolis "where you find yourself in the presence of a loathsome thing that is known as Methodism and Money".[17]

Such a society could hardly countenance the public exhibition of paintings of the nude. But, in the words of Samuel Johnson, "Most vices may be committed very genteelly". The men's room of a tavern, off limits to the ladies, might display its nude behind the bar, and a gentleman might hang his in the billiard room. As we have already noted, nudes of a classical nature were permissable as part of a decorative scheme in theatres or lounges. Inevitably this outlook spawned a considerable number of artists whose works perfectly met the requirements of inoffensive titillation; for example, the painters William Etty in England, William Bouguereau in France and the American sculptor Hiram Powers. A marble titled *Greek Slave*, by Powers, made a sensation when it was shown in New York in 1847. These were artists of considerable ability, and both Etty and Bouguereau produced some fine paint-

ings. A Canadian equivalent is Willis Romanow, whose beautifully executed and saucy drawings, such as *Cat No 2* (Pl 68), have always been in great demand.

Apart from the question of social acceptability, the kind of paintings produced in any particular period is understandably influenced by the general direction of public interest and taste in the arts. The nineteenth century witnessed the greatest development of landscape painting in Western art as a subject in its own right. Naturally, in a relatively new country like Canada the main preoccupation was with its physical characteristics. Early artists such as Paul Kane, who followed the pioneers in the extension of the frontier westward, usually included the indigenous people in their paintings, presumably because they regarded them as being part of the landscape. But later artists portrayed the Canadian scene devoid of figures. Practically none appear in the works of the Group of Seven, Emily Carr and David Milne, because the inspiration of these artists was the land itself. In Carr's paintings one can sense the spiritual presence of the Indians, and in those of Milne that of the settlers of Ontario, but the people themselves are seldom physically present.

But now the vast land, once regarded as limitless, has been seen to be finite, and the largest fresh-water lakes in the world have been soiled. Our concern is once more focussed on man and his relationship with the environment. The problems of our time are social, and concentrated in the metropolitan areas, and one would expect contemporary art to reflect the new orientation. That it does is evidenced by the vigorous revival of interest among artists in figurative painting.

One consequence of this revival has been the restoration of the nude to its historic position as a vehicle of expression.

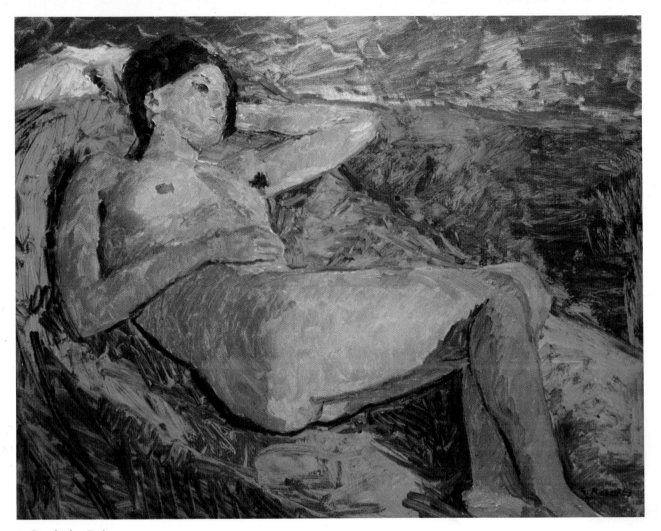

1 Goodridge Roberts
Reclining Nude 1961 Oil 40″ × 48″
Artlenders, Montreal

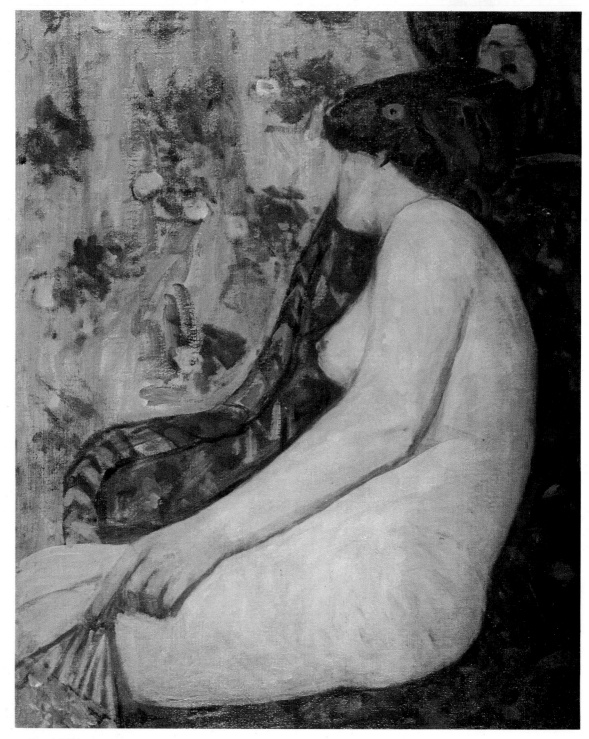

2 James Wilson Morrice
Nude Study Oil 25″ × 20″
Private collection

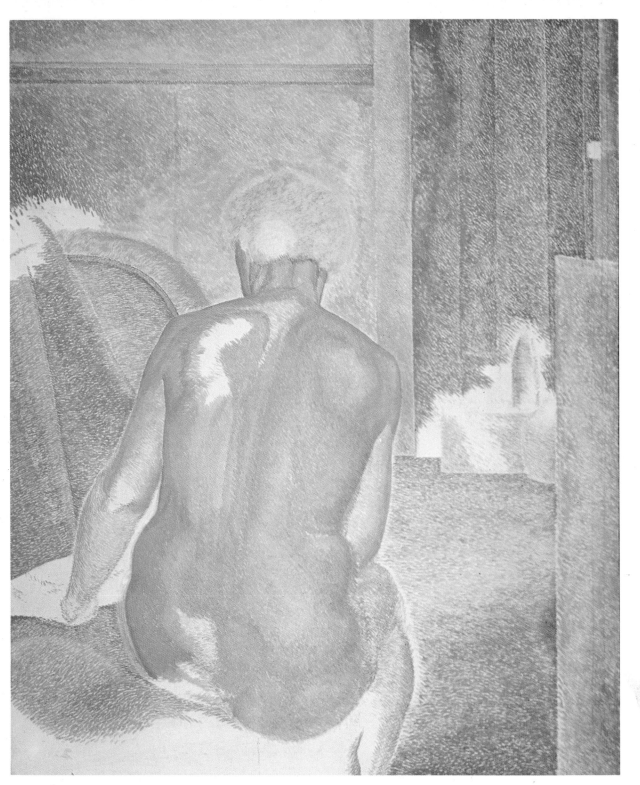

3 Lionel LeMoine FitzGerald
Nude in an Interior Oil 46″ × 38″
Mr J. Hanson, Toronto

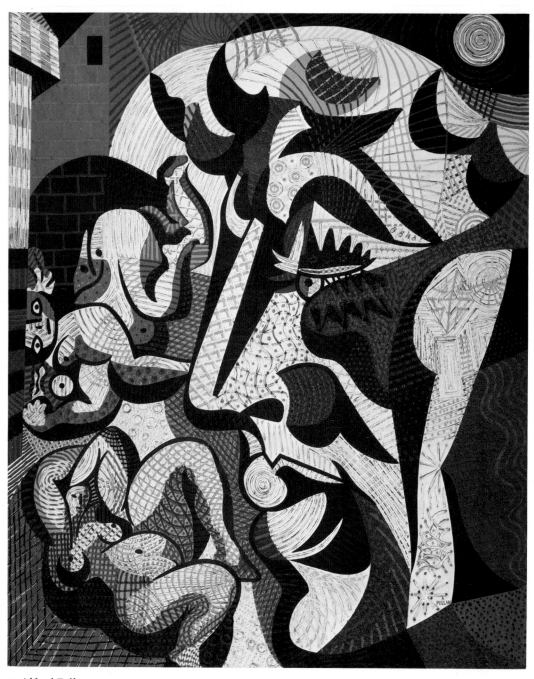

4 Alfred Pellan
Sur la Plage 1952 Oil 81¾" × 66"
The National Gallery of Canada, Ottawa

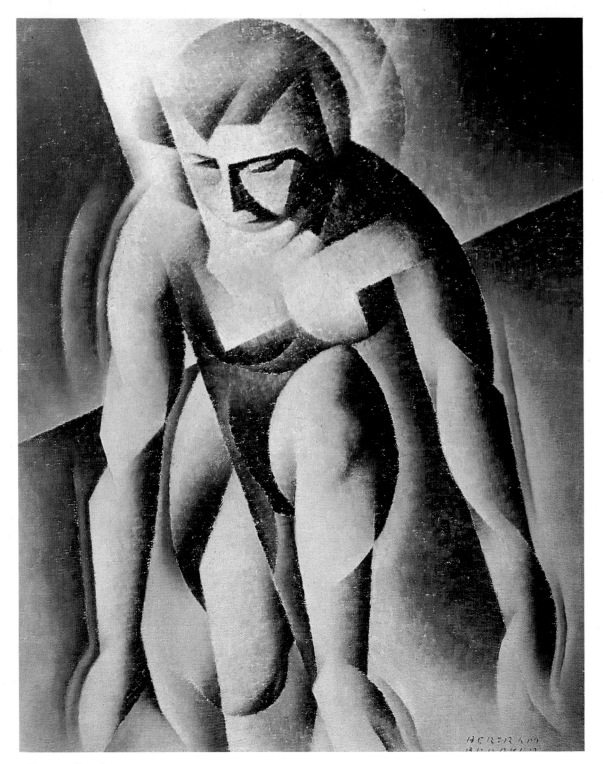

5 Bertram Brooker
Kneeling Nude c. 1940 Oil 24″ × 18″
Bertram Brooker Estate

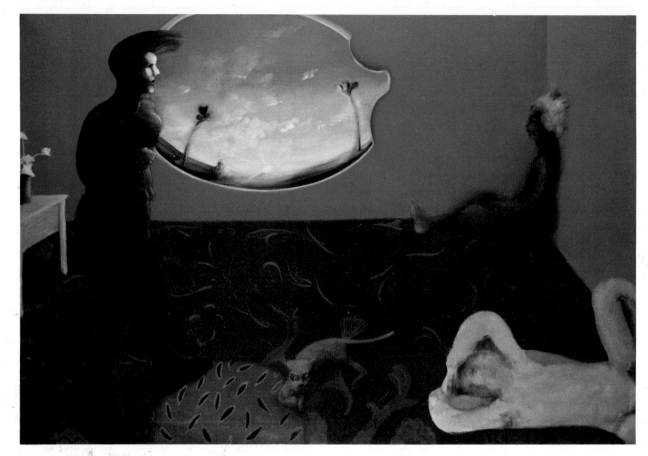

6 Louis de Niverville
Morning 1970 Acrylic 48″ × 72″
Collection: The Artist

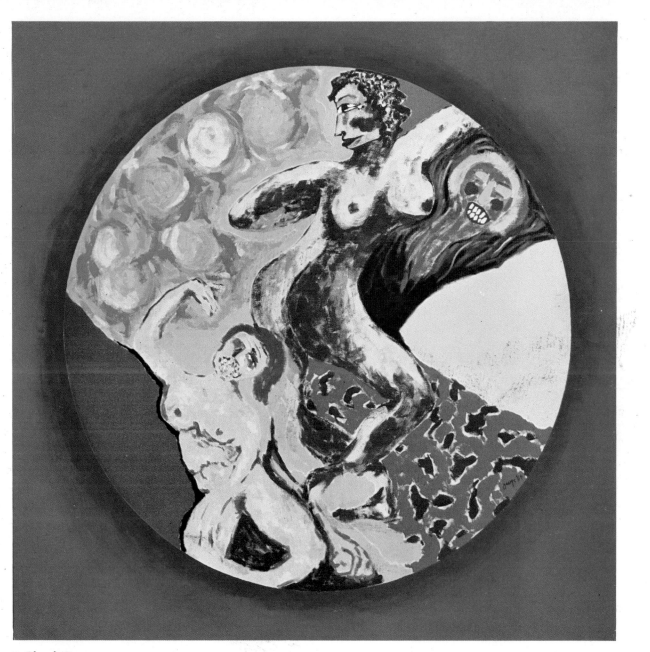

7 Claude Breeze
Lovers in a Landscape #3, Mandala 1967 Acrylic 46″ × 46″
Mr and Mrs Peter Gzowski, Toronto

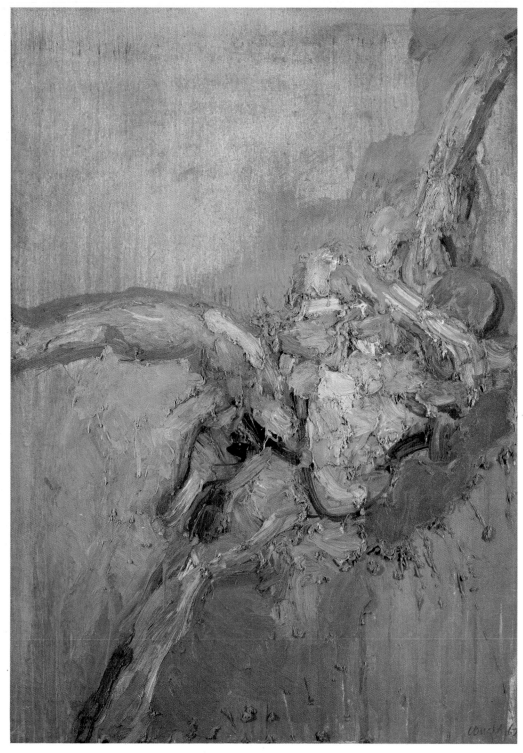

8 Graham Coughtry
Two Figures #5 1962 Oil and lucite 70″ × 50″
The National Gallery of Canada, Ottawa

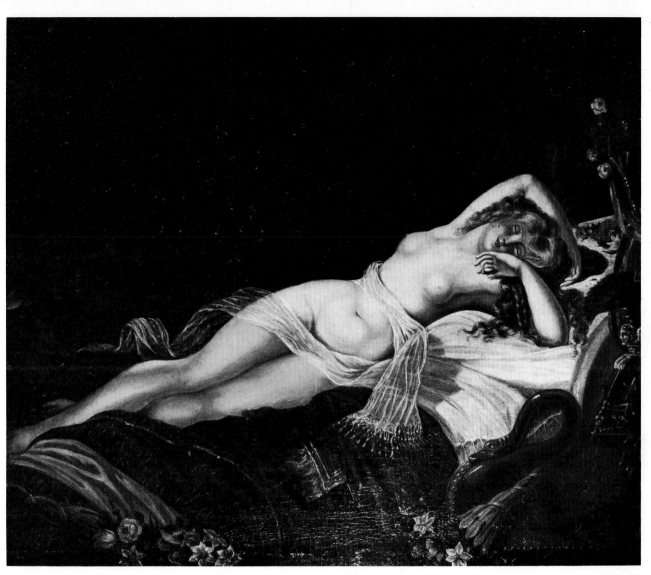

9 Cornelius Krieghoff
Nude 1844 Oil 25″ × 34″
Destroyed. Photo courtesy Robertson Gallery, Ottawa

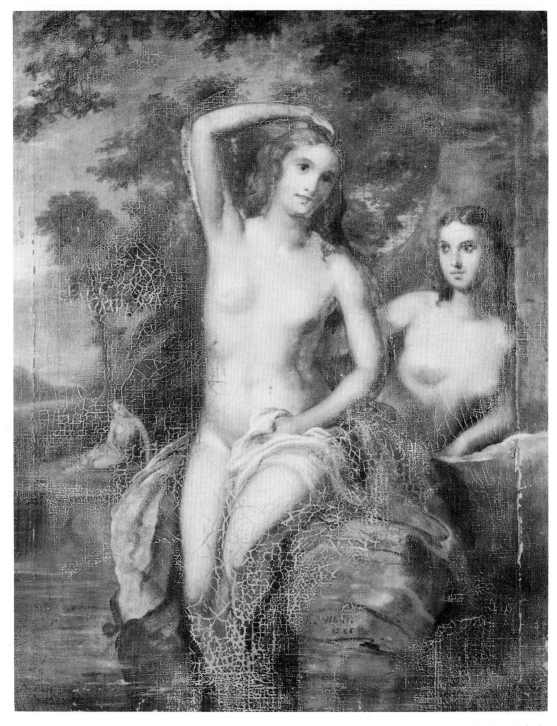

10 Robert Whale
Bathers 1866 Oil 25″ × 21″
Collection: Glenhyrst Commission, Brantford

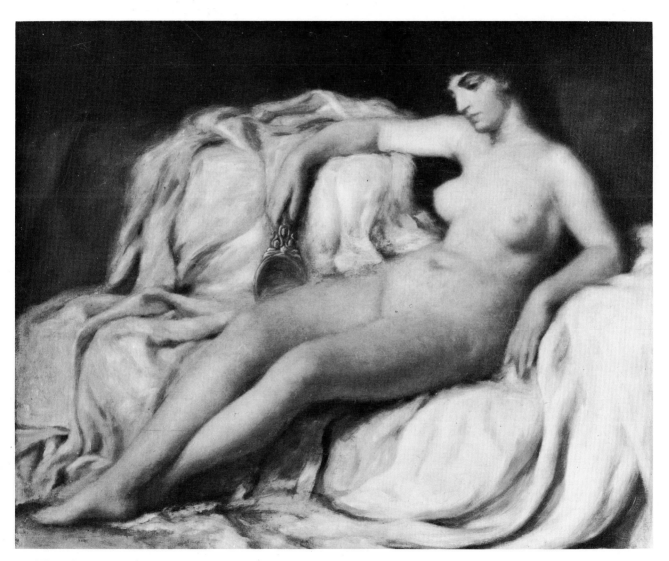

11 Wyatt Eaton
Eve 1879 Oil 28″ × 36″
The Montreal Museum of Fine Arts

38

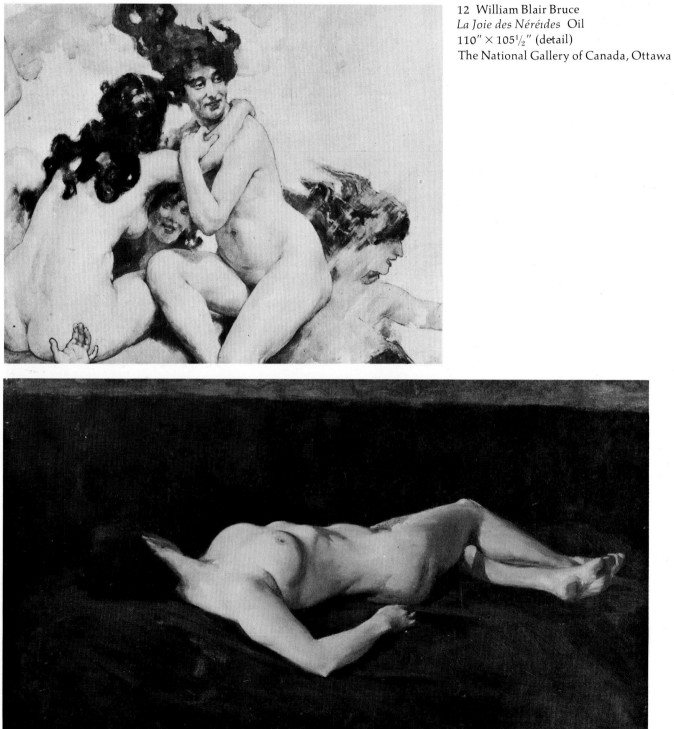

12 William Blair Bruce
La Joie des Néréides Oil
110″ × 105½″ (detail)
The National Gallery of Canada, Ottawa

13 William Brymner
Reclining Figure Oil 18¼″ × 34³/₁₆″
The Montreal Museum of Fine Arts

14 Paul Peel
The Little Shepherdess Oil 63¼" × 44⅞"
The Art Gallery of Ontario, Toronto

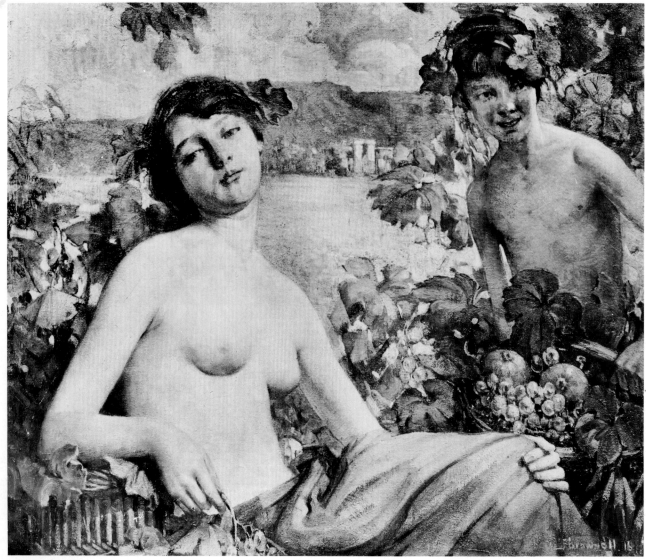

15 Franklin Brownell
The Golden Age Oil 28¼″ × 34½″
The National Gallery of Canada, Ottawa

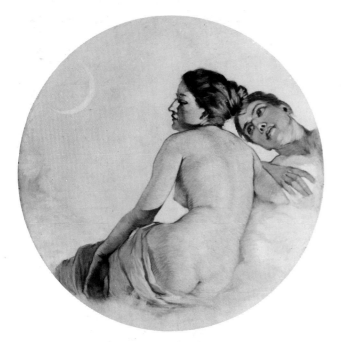

16 Frederick S. Challener
Roundel, *Dusk* from the Russell Theatre 1901 Oil 51″ diam
The National Gallery of Canada, Ottawa, Study Collection

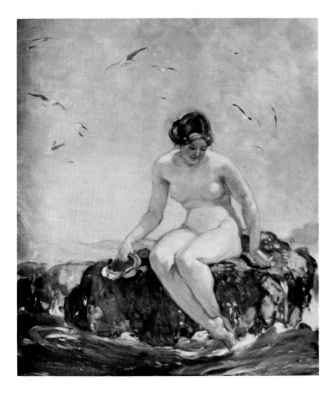

17 Frederick S. Challener
Aphrodite's Realm Oil 30″ × 26″
The National Gallery of Canada, Ottawa

18 Joseph-Charles Franchère
Sylphide Oil 46″ × 33″
The National Gallery of Canada, Ottawa

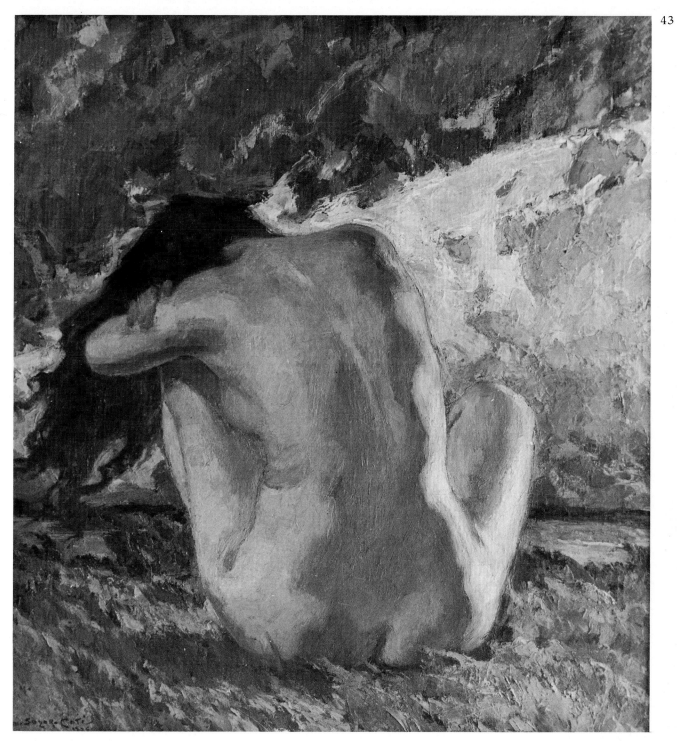

19 Aurèle de Foy Suzor-Coté
Symphonie Pathétique 1925 Oil 49¹⁄₈″ × 44¹⁄₈″
Musée du Québec

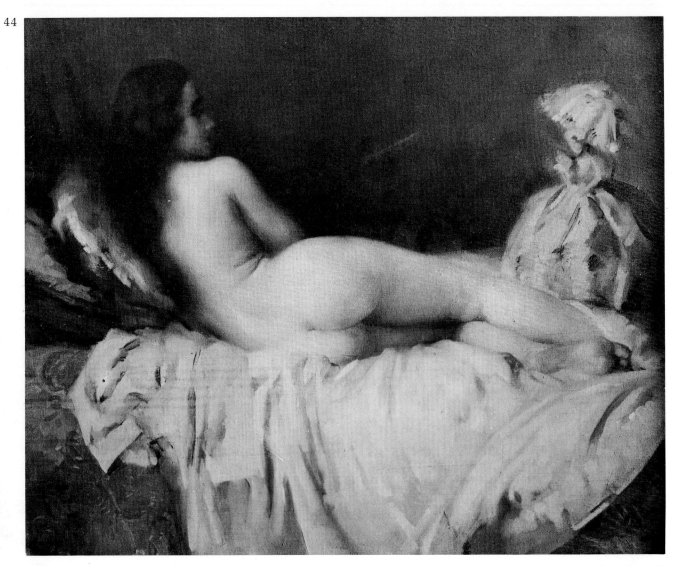

20 John Russell
Nude Resting Oil 29″ × 37″
Mrs Ian Johnston, Toronto

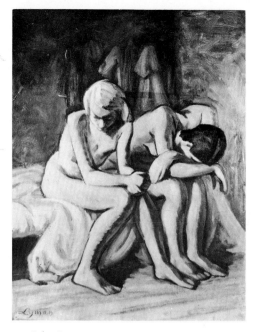

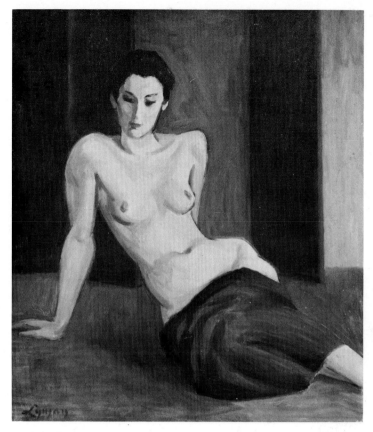

21 John Lyman
Trouble
Present whereabouts unknown

22 John Lyman
Nu Citrine Oil $30\frac{1}{8}'' \times 26\frac{1}{8}''$
Dominion Gallery, Montreal

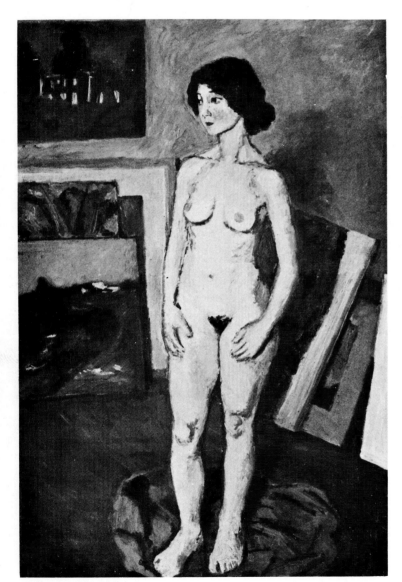

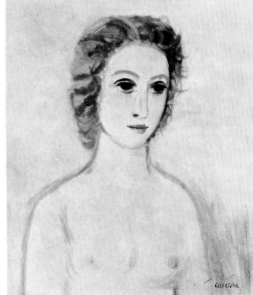

24 Stanley Cosgrove
Anne Oil 24″ × 20″
Dominion Gallery, Montreal

23 Goodridge Roberts
Nu debout 1951 Oil 48″ × 32″
Private collection, Montreal

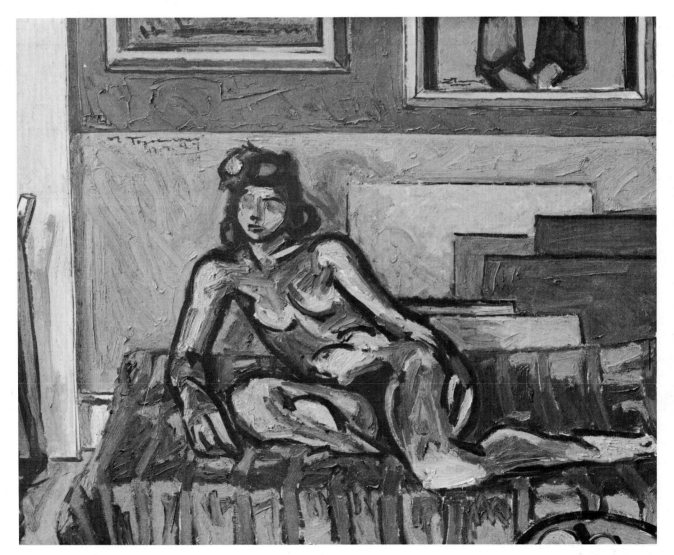

25 Jacques de Tonnancour
Le grand nu, au divan rouge 1944 Oil 28″ × 35″
Musee d'Art Contemporain, Montreal

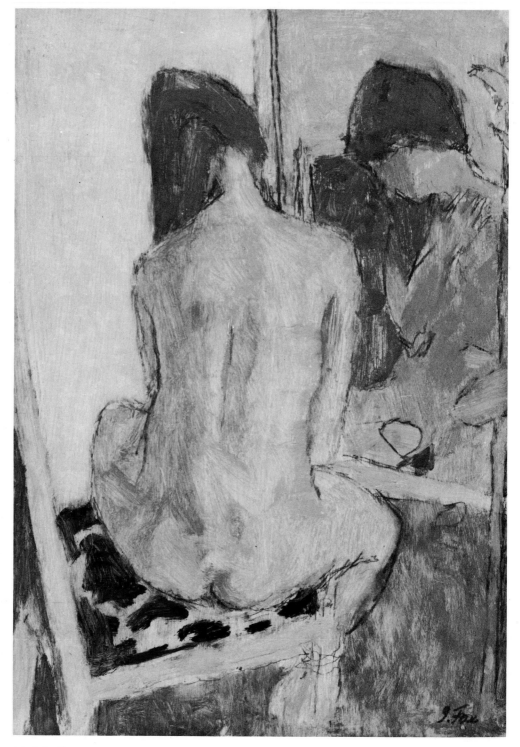

26 John Fox
Model at Mirror 1970 Acrylic 32″ × 14″
Galerie Godard Lefort, Montreal

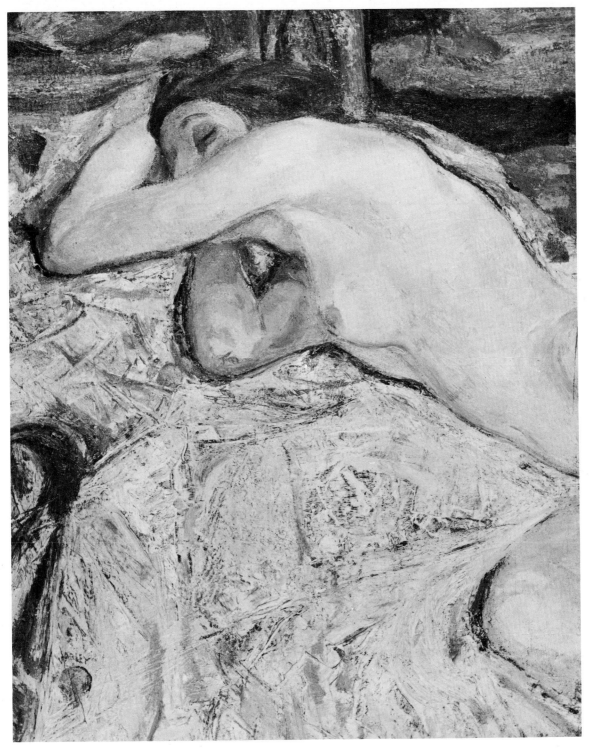

27 Frederick H. Varley
Nude on a Couch 1931 Oil 17⅞″ × 13⅞″
C. S. Band Collection, Toronto

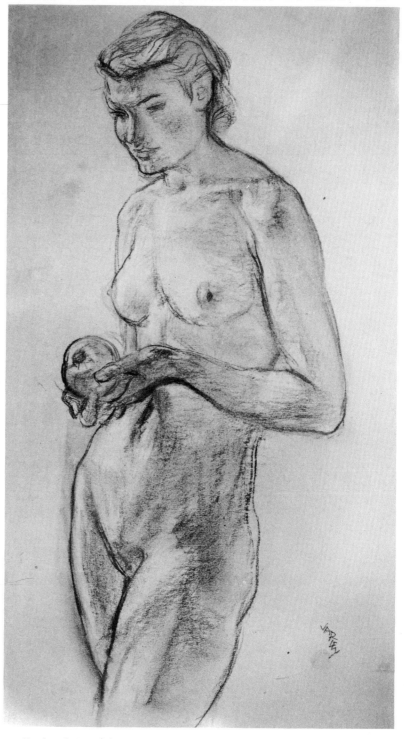

28 Frederick H. Varley
Nude with Apple Crayon
C. S. Band Collection, Toronto

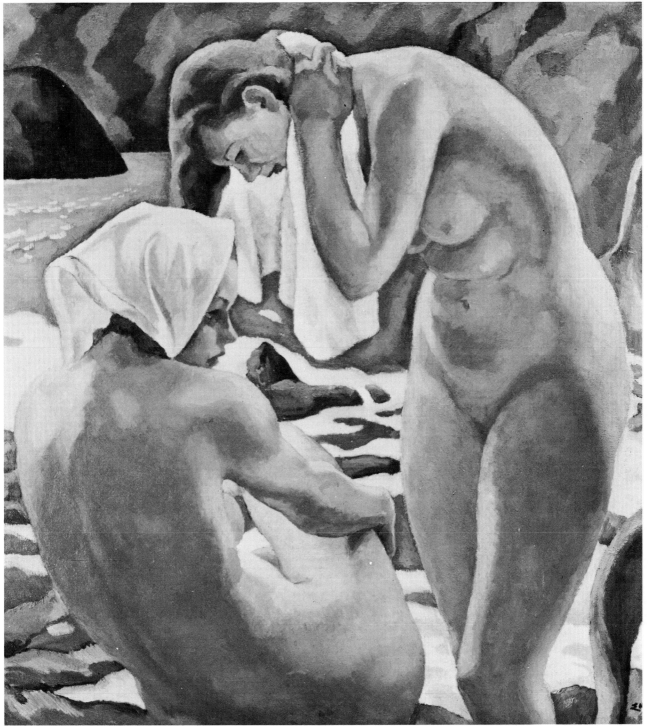

29 Edwin Holgate
The Bathers c. 1935 Oil 32″ × 32″
The Montreal Museum of Fine Arts

30 Randolph Hewton
Sleeping Woman 1929 Oil 40″ × 60″
The National Gallery of Canada, Ottawa

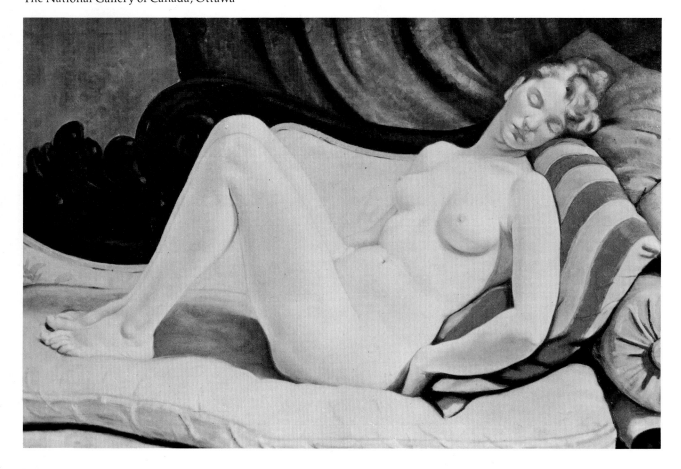

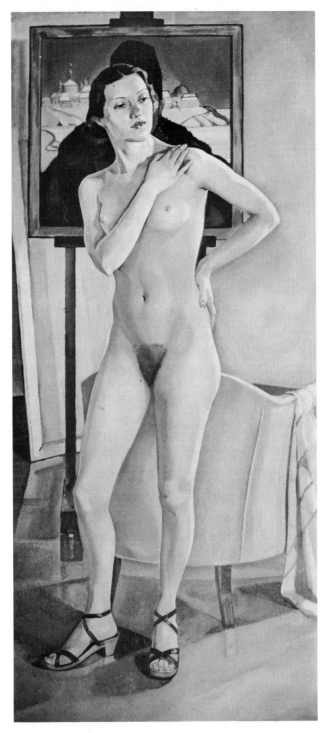

31 Lilias Torrance Newton
Nude in the Studio Oil
Private collection

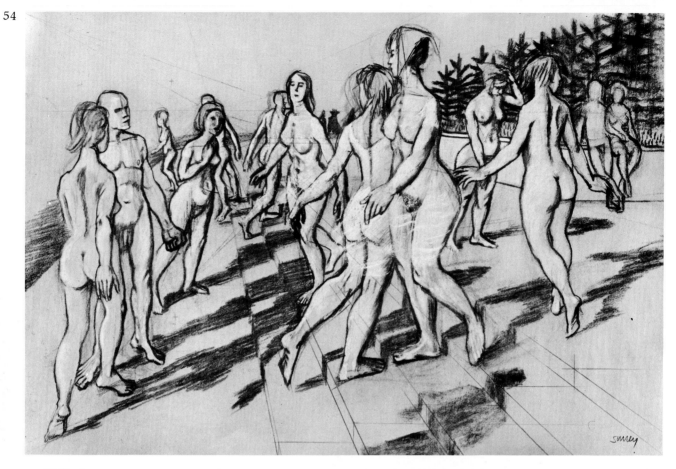

32 Philip Surrey
Study for Place Ville Marie
Chalk 24″ × 36″
Collection: The Artist

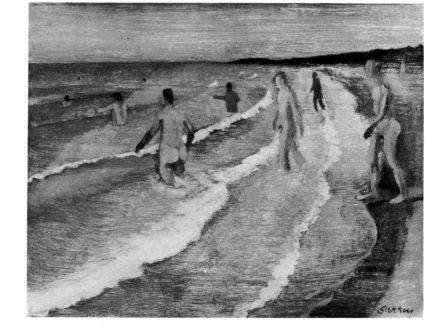

33 Philip Surrey
Nude Men wading into the Sea
Oil 6″ × 8″
Collection: The Artist

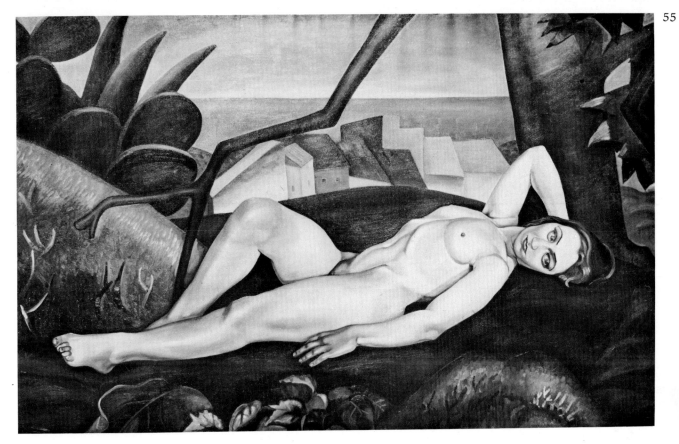

34 Prudence Heward
Girl under a Tree c. 1935 Oil 48" × 76"
The Art Gallery of Hamilton

35 Bertram Brooker
Eve Ink 9″ × 12″
Private collection, Toronto

36 Will Ogilvie
Figure Study c. 1930 Oil 36″ × 24″
Private collection

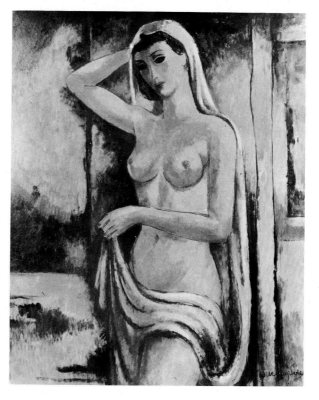

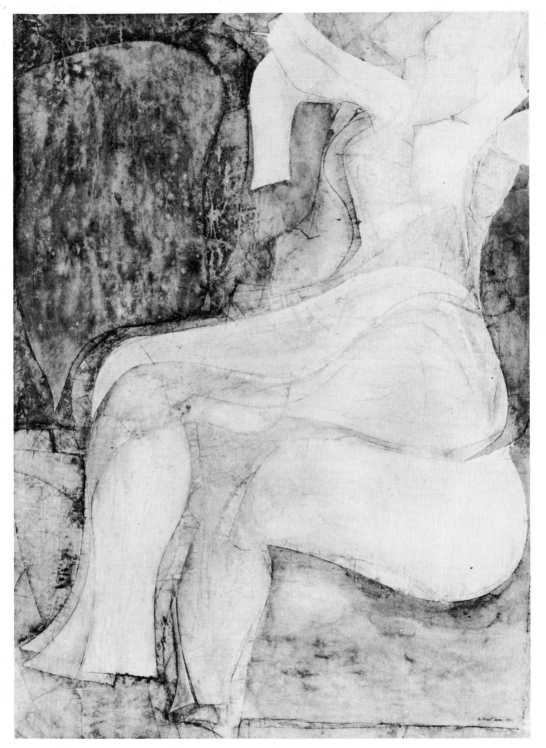

37 Michael Snow
Seated Nude 1955 Painted collage 40″ × 30″
Mr and Mrs Percy Waxer, Toronto

38 Bruno Bobak
Nude with Black Stockings 1966 Oil 31″ × 48″
Dr Paul Tacon, King

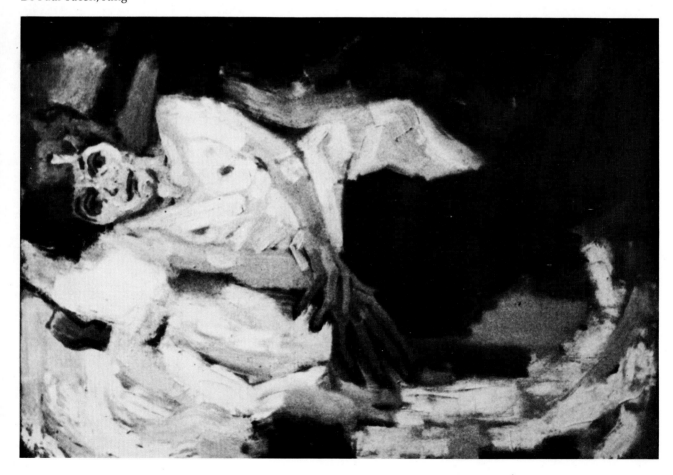

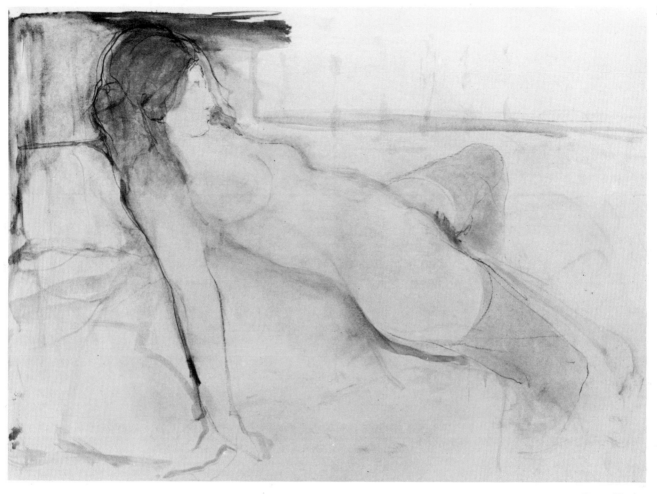

39 Peter Harris
In Repose 1971 Watercolour 24″ × 38″
The Roberts Gallery, Toronto

60 40 Robert Markle
*Drawing for Pale Blue
Marlene #3* Charcoal and
tempera 35″ × 23″
The Isaacs Gallery,
Toronto

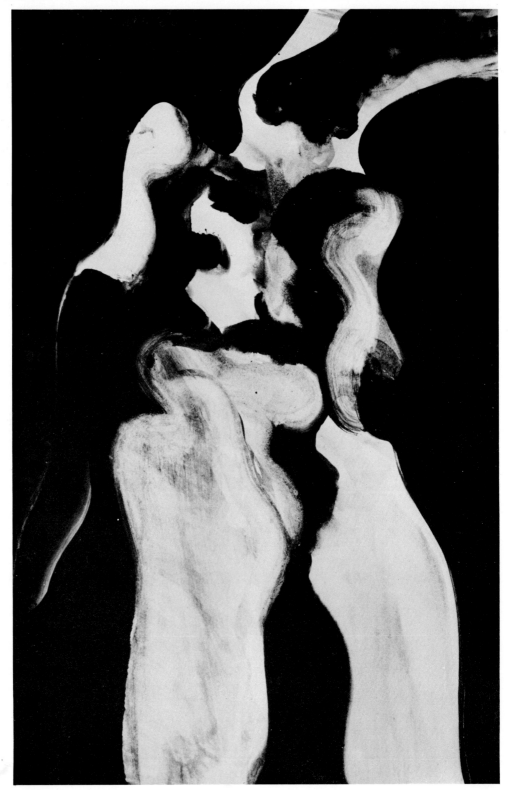

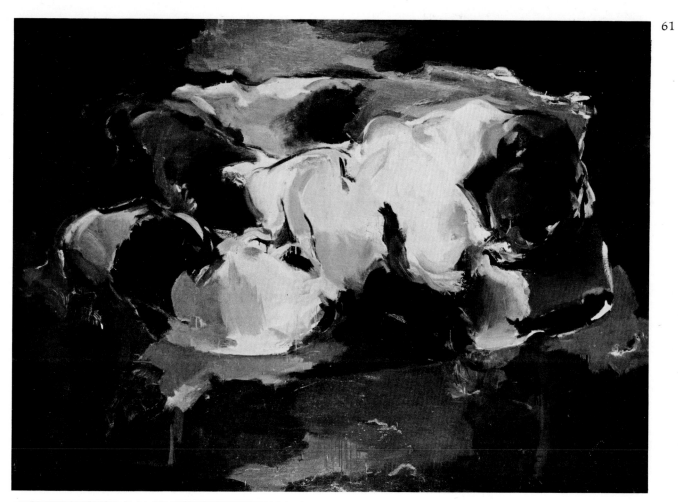

41 Robert Hedrick
Homage to Goya 1964 Oil 60″ × 84″
Collection: The Artist

62

42 Gerald Gladstone
Downtown Nudes 1969 Oil 54″ × 45″
Collection: The Artist

43 Mashel Teitelbaum
Startled Woman 1971
Acrylic mounted on canvas 22″ × 30″
Collection: The Artist

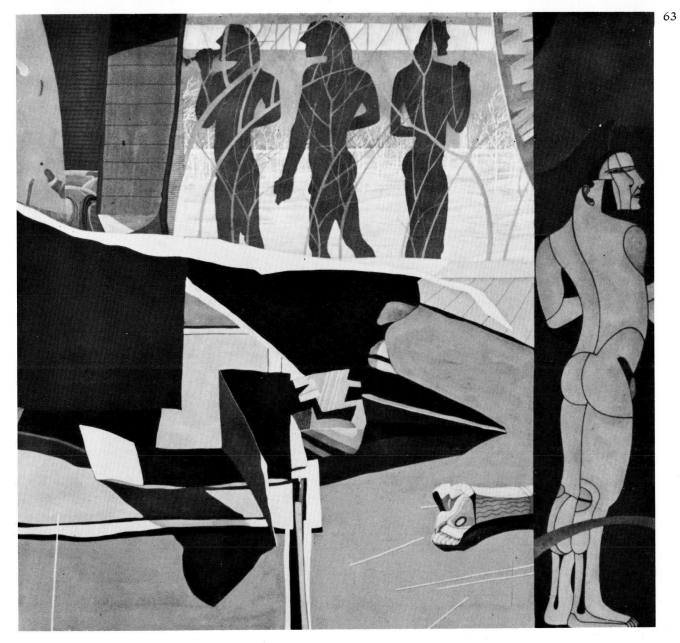

44 Ivan Eyre
Stills: Willows 1970 Acrylic 68″ × 72″
York Downs Golf and Country Club, Unionville

45 Jan Menses
Klippoth Series 1967 Tempera on paper 30″ × 22″
Collection: The Artist

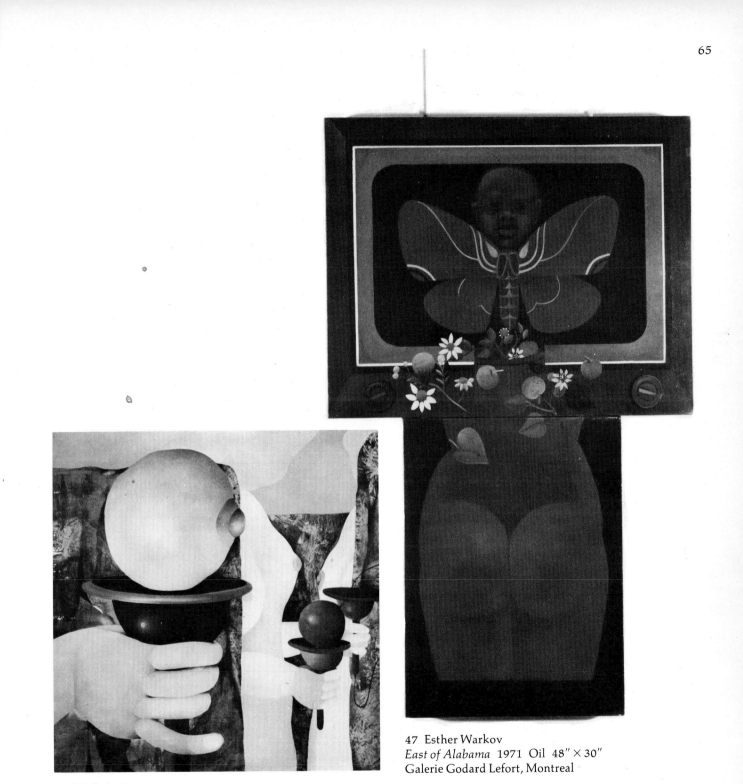

46 Michele Bastin
Bilboquet II 1970 Oil 50″ × 50″
Collection: The Artist

47 Esther Warkov
East of Alabama 1971 Oil 48″ × 30″
Galerie Godard Lefort, Montreal

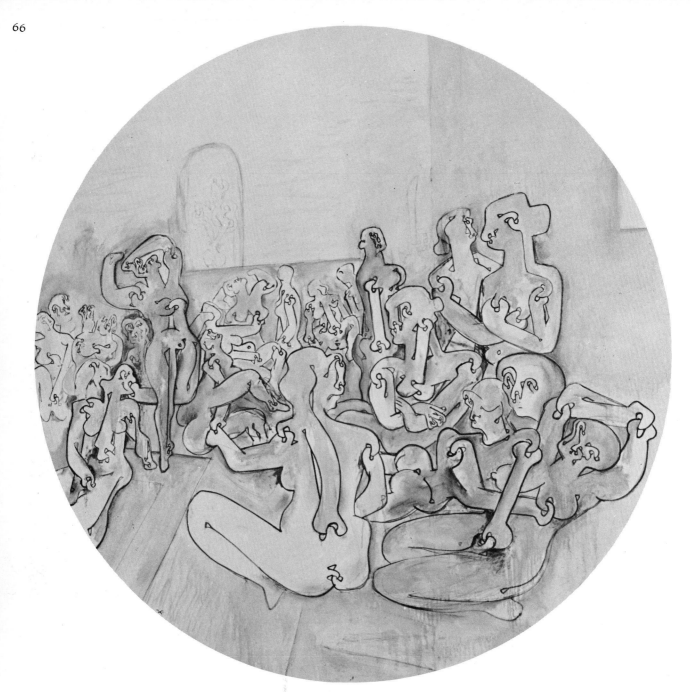

48 Sorel Etrog
Study after Ingres' Turkish Bath 1969 Oil 79″ diam
Dunkelman Gallery, Toronto

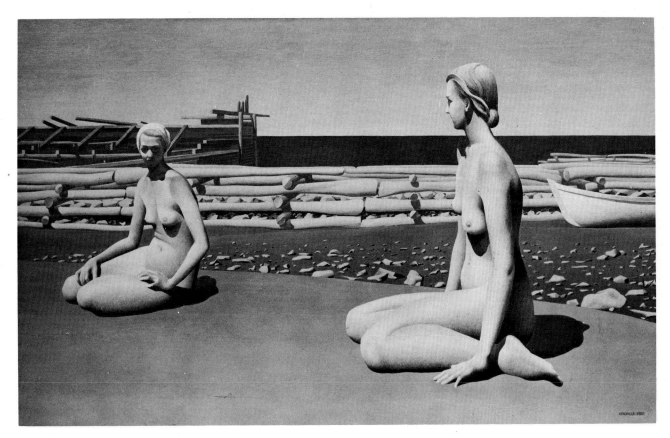

49 Alexander Colville
Nudes on the Shore 1950 Tempera on board 24″ × 38¾″
The Beaverbrook Art Gallery, Fredericton

50 T. R. MacDonald
The Letter 1970 Oil 48″ × 36″
Private collection

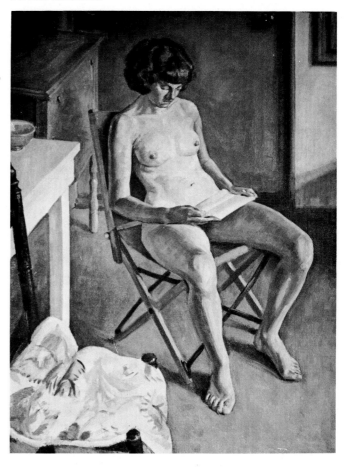

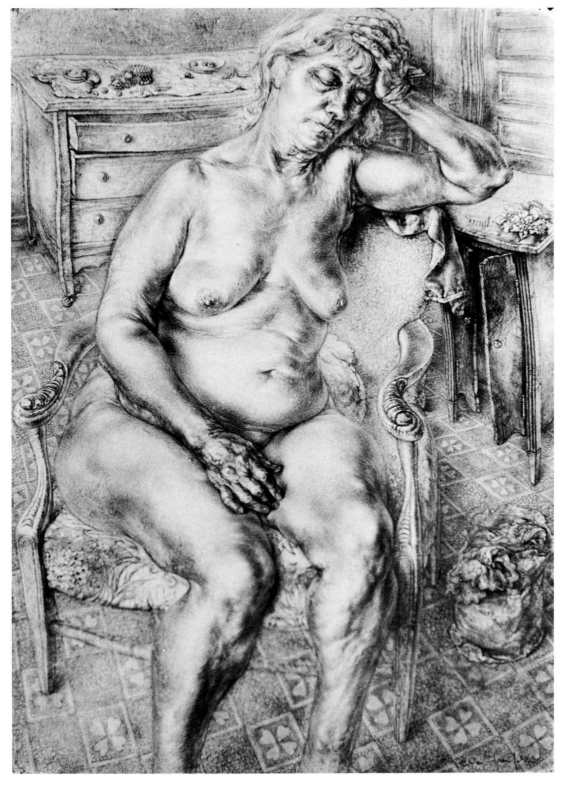

51 Eric Freifeld
Pauline 1969
Watercolour
31⅛″ × 22⅝″
Collection:
The Artist

70

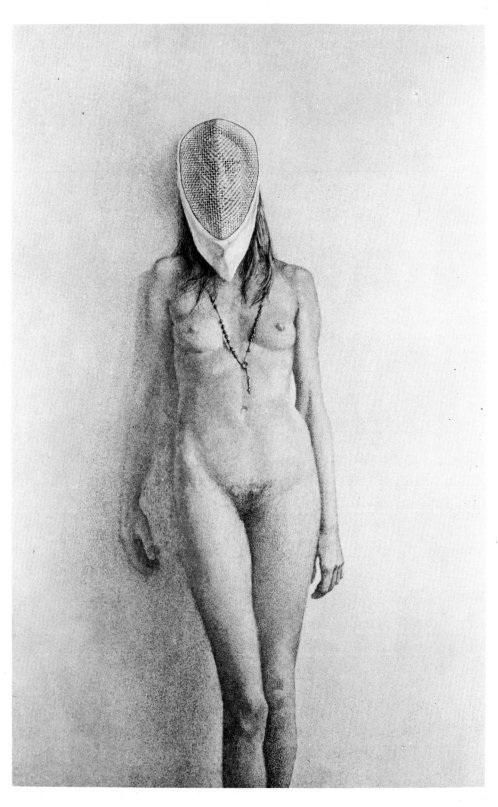

52 Hugh Mackenzie
Girl in a Fencing Mask
1970 Tempera 36″ × 24″
Collection: The Artist

53 John Leonard
Portrait 1971 Acrylic
72″ × 48″
Pollock Gallery, Toronto

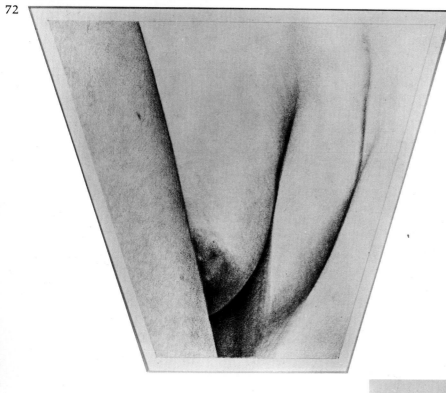

54 Clyde McConnell
Untitled Pencil 16″ × 16¼″
Collection: The Artist

55 Warren Peterson
Untitled Charcoal 30″ × 22″
Collection: The Artist

56 Greg Curnoe
Spring on the Ridgeway 1965
Oil and mixed media 73⅝″ × 73⅝″
The Art Gallery of Ontario, Toronto

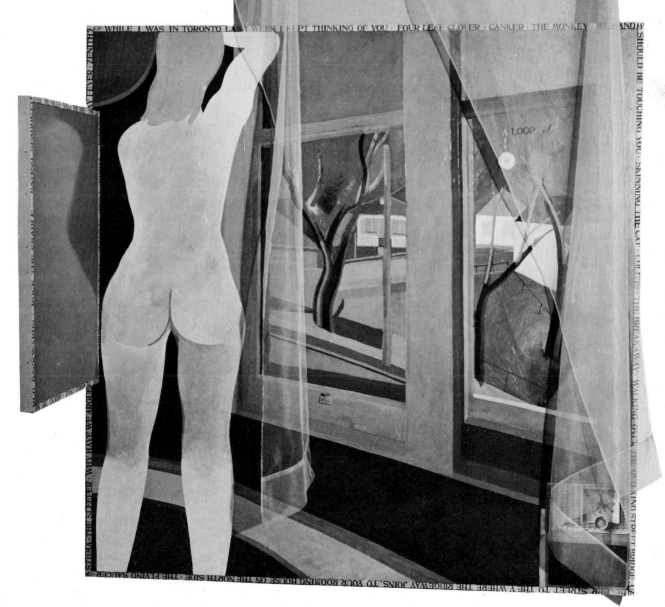

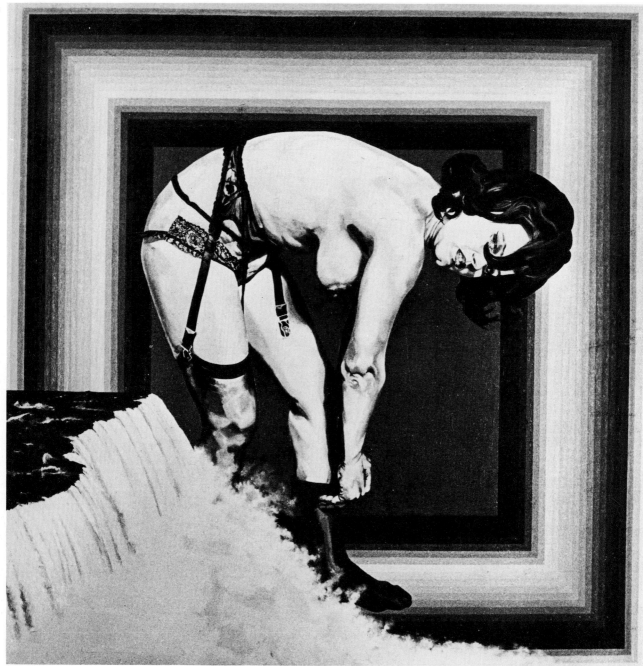

57 Dennis Burton
Niagara Rainbow Honeymoon # 1 – The Bedroom 1968 Oil 60″ × 60″
The Winnipeg Art Gallery

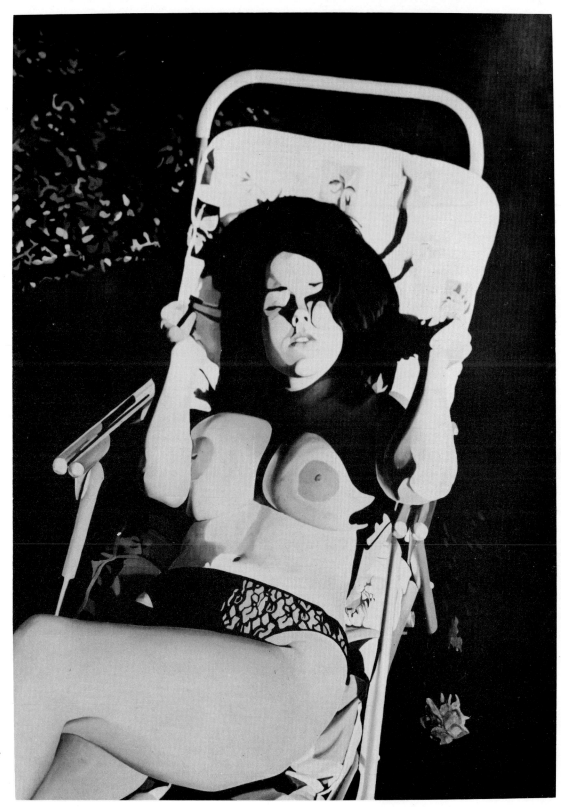

58 James Spencer
Margaret 1971
Acrylic 84″ × 60″
Collection:
The Artist

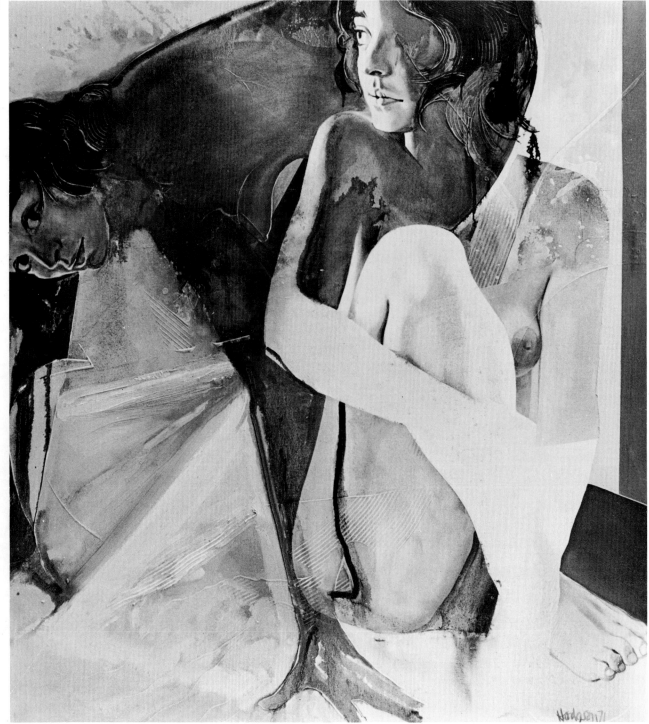

59 Tom Hodgson
Maria #1 1970 Acrylic 50" × 46"
Collection: The Artist

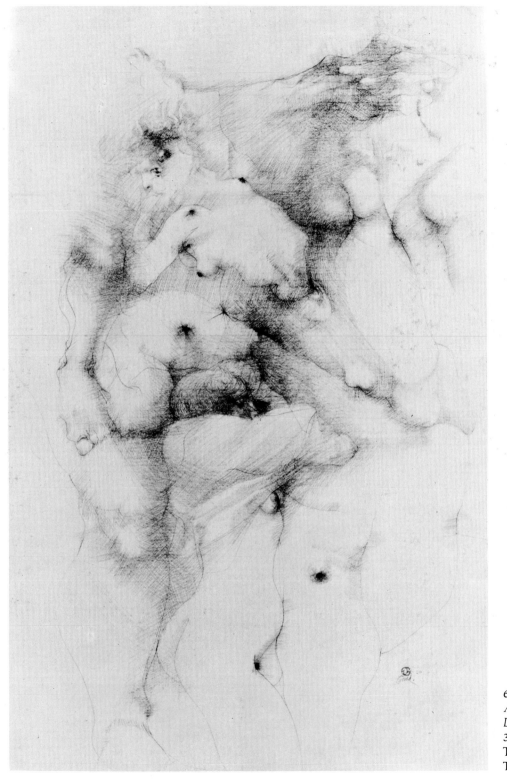

60 John Gould
*Ancestors #1: Film
Drawing* 1966 Crayon
36″ × 23″
The Roberts Gallery,
Toronto

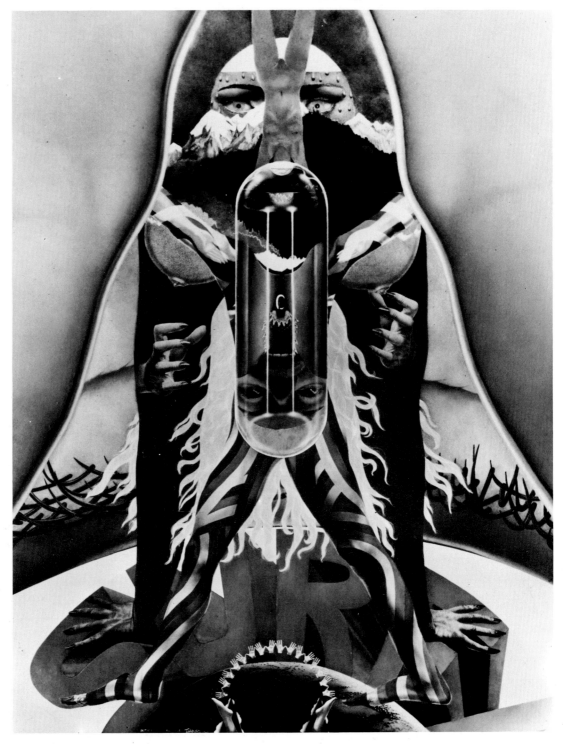

61 Richard Turner
Initiates of the All Over 1970 Coloured inks 36″ × 28″
Mr R. J. Longstaffe, Vancouver

62 John Boyle
Lakeside Park 1970 Acrylic
72″ × 120″ (detail)
Nancy Poole Studio, Toronto

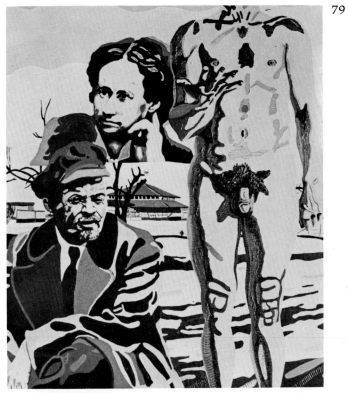

63 John Boyle
Ontario Street 1970 Acrylic
96″ × 168″
Nancy Poole Studio, Toronto

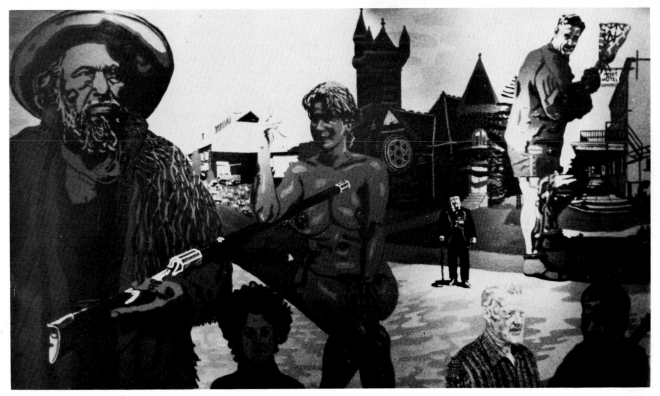

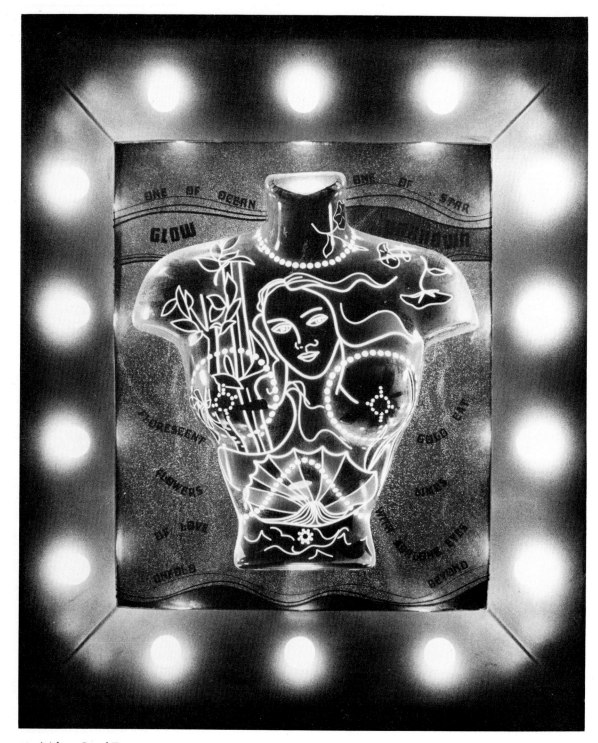

64 Audrey Capel Doray
Rebirth of Venus 1968 Composite photo of transmitted and reflected light realities.
Lighting programmed for 20-second cycle of varying light phases.
Collection: The Artist

65 Michael Morris
Studies for Drawings to be Filmed 1970
Courtesy the artist

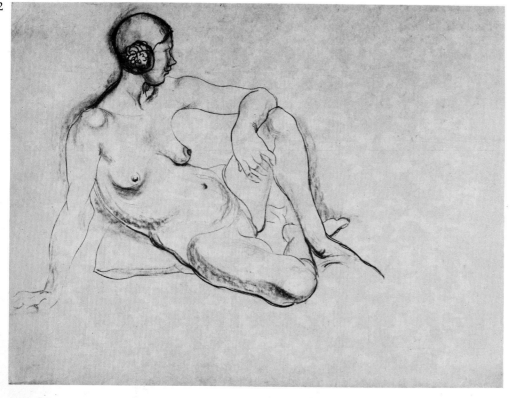

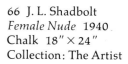

66 J. L. Shadbolt
Female Nude 1940
Chalk 18″ × 24″
Collection: The Artist

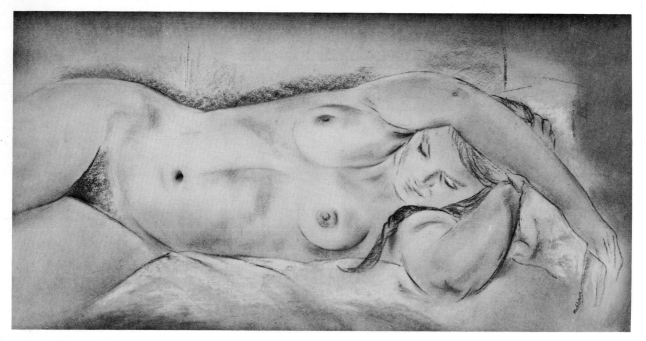

67 Louis Muhlstock
Reclining Nude 1970 Mixed media 23″ × 39″
Private collection, Montreal

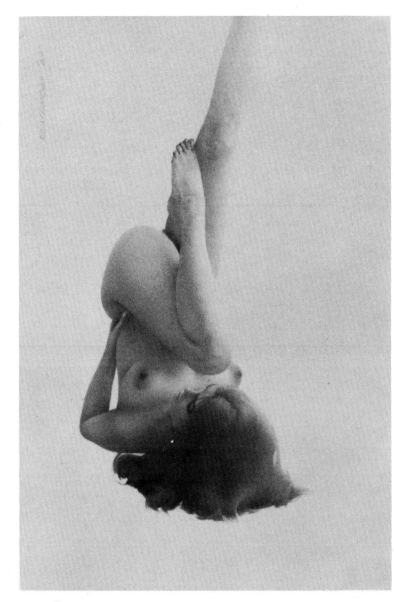

68 Willis Romanow
Cat No 2 1969 Pencil 11½″ × 7½″
Mr and Mrs Phillip de Zwirek, Toronto

69 Christopher Pratt
Donna 1970 Pencil 18¼″ × 12″
Mr and Mrs E. C. Bovey, Toronto

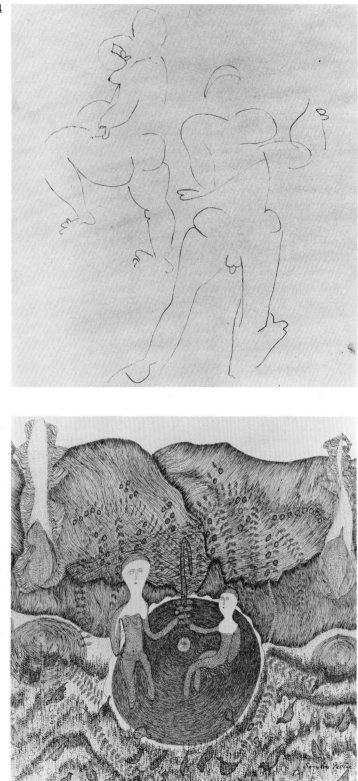

70 Joyce Wieland
Lovers # 26 1961 Pencil 10″ × 8″
Mr and Mrs G. H. Montaque, Toronto

71 Sindon Gécin
Adam and Eve 1962 Pen and ink 16″ × 16″
Mr and Mrs Moe Levin, Montreal

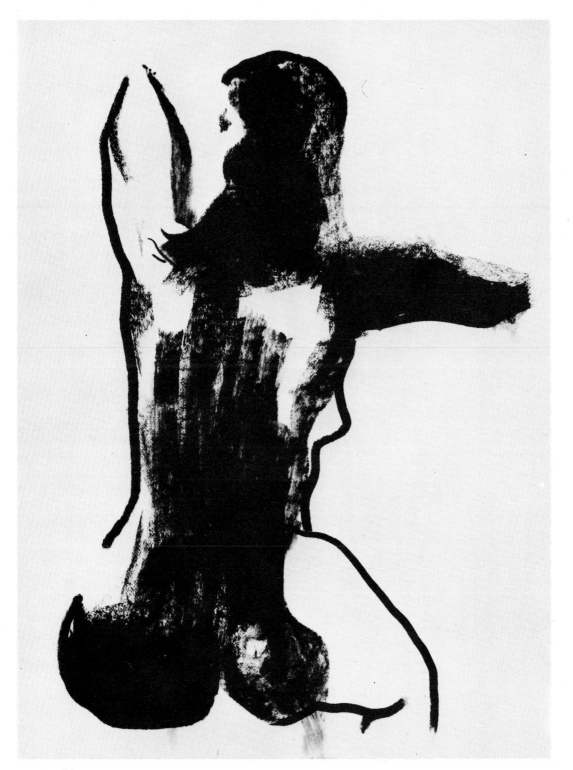

72 Harold Town
Seated Nude 1961 Charcoal 29³/₄″ × 22″
The Mazelow Gallery, Toronto

1 J. Russell Harper, *Painting in Canada* (Toronto: University of Toronto Press, 1966), p. 221.

2 Ibid., p. 252.

3 Marius Barbeau, *Cornelius Krieghoff* (Toronto: McClelland and Stewart, 1962), p. 4.

4 Aleister Crowley, *The Confessions of Aleister Crowley* (London: Jonathan Cape, 1969), p. 502.

5 John Lyman, *Morrice* (Montreal: Les Editions de l'Arbre, 1945), p. 10.

6 John Lyman in the column "Art World", *Saturday Night*, Vol. 52, No. 18 (March 6, 1937), p. 10.

7 Lawren Harris, "Revelation of Art in Canada", *The Canadian Theosophist*, Vol. VII (July 15, 1926), p. 85.

8 Thomas R. Lee, "Bertram Brooker 1888-1955" in *Canadian Art*, Vol. XIII (Spring 1956), pp. 286-91.

9 See *Arts Canada*, Vol. XXVI (October 1969), p. 24.

10 See *Arts Canada*, Vol. XXV (December 1968), p. 51.

11 See *Arts Canada*, Vol. XXVII (October/November 1970), p. 52.

12 From an article in *La Grande Revue*, 1908.

13 Jack Shadbolt, *In Search of Form* (Toronto: McClelland and Stewart, 1968), p. 34.

14 See *Harold Town Drawings* (Toronto: McClelland and Stewart, 1969).

15 Sindon Gécin in a statement in the catalogue of an exhibition at Galerie Dresdnère, Montreal, 1959.

16 See Chapter III of James Thomas Flexner, *A Short History of American Painting* (Boston: Houghton Mifflin Company, 1950).

17 John Rothenstein, *Time's Thievish Progress* (London: Cassell, 1970), p. 33.

(of painters whose works are reproduced—
numbers refer to plates)